Margrethe Mather
&
Edward Weston

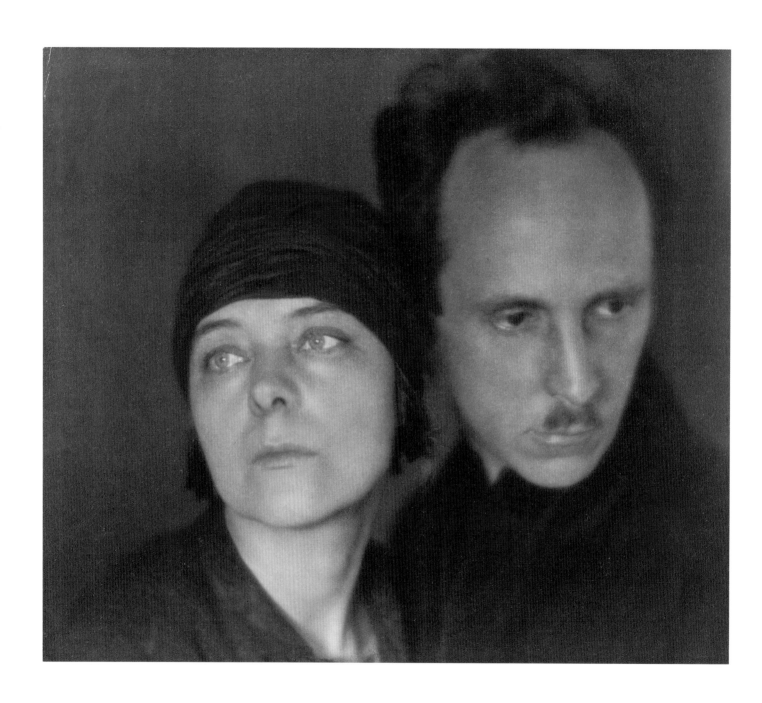

Imogen Cunningham, *Margrethe Mather and Edward Weston*, 1922, platinum/palladium print.
© Imogen Cunningham Trust. Collection Center for Creative Photography, University of Arizona, Tucson.

Margrethe Mather
&
Edward Weston

A Passionate Collaboration

BETH GATES WARREN

SANTA BARBARA MUSEUM OF ART
IN ASSOCIATION WITH
W. W. NORTON & COMPANY NEW YORK LONDON

This book is composed in Cochin
Manufacturing by Mondadori Printing, Verona, Italy
Book design by Katy Homans

Front cover: *Edward Weston and Margrethe Mather, 1922*
Photograph by Imogen Cunningham
© 1970 The Imogen Cunningham Trust

Back cover: *Maud Emily Taylor Seated in Chinese Chair*, ca. 1918
Photograph by Margrethe Mather

Library of Congress Cataloging-in-Publication Data
Warren, Beth Gates.
Margrethe Mather & Edward Weston: A passionate collaboration / Beth Gates Warren.
p. cm.
Includes bibliographical references and index.
ISBN 0-393-04157-3
1. Mather, Margrethe — Relations with men. 2. Weston, Edward, 1886–1958. 3. Women photographers —
United States — Biography. 4. Photographers — United States — Biography. I. Title.
TR140.M353 S37 2001
770'.92 — dc21
[B]

2001031145

W. W. Norton & Company, Inc., 500 Fifth Avenue, New York, N.Y. 10110
www.wwnorton.com

W. W. Norton & Company Ltd., Castle House, 75/76 Wells Street, London W1T 3QT

1 2 3 4 5 6 7 8 9 0

Photography Credits
Ben Blackwell: pp. 46 [pl. 7], 68 [pl. 29]
Phillip Gagliani: p. 33 [fig. 23]
Scott McClaine: pp. 34 [fig. 26], 44 [pl. 5], 45 [pl. 6], 48 [pl. 9], 51 [pl. 12],
52 [pl. 13], 58 [pl. 19], 59 [pl. 20], 60 [pl. 21], 72 [pl. 33], 80 [pl. 51]

Grateful acknowledgment is made for permission to quote from the following sources:
Quotations from *The Daybooks of Edward Weston*, text by Edward Weston, © 1981 Arizona Board of Regents,
Center for Creative Photography, University of Arizona; from Nancy Newhall's introduction to
The Daybooks of Edward Weston, © 1960, The Estate of Beaumont Newhall and Nancy Newhall,
Courtesy of Scheinbaum and Russek Ltd., Santa Fe, New Mexico;
and from Imogen Cunningham's correspondence,
Courtesy of The Imogen Cunningham Trust, Berkeley, California.

Contents

Introduction

In a talk at the Santa Barbara Museum of Art, the renowned collector Michael Wilson noted that one of the most exciting aspects of the history of photography is that it is still being written. It is still possible to make significant scholarly contributions to the field, and to discover important, little-known bodies of work.

The "late Miss Mather," as Edward Weston referred to Margrethe (she was perennially tardy), is a perfect example. Although she has been represented in nearly every important survey exhibition of the time, she is absent from almost all written photographic histories and has remained an elusive, intriguing figure. Her images hold their own in the company of other great photographs, yet the woman herself is hardly mentioned except in relation to Edward Weston.

When Beth Gates Warren and I met in 1995, we discovered a shared curiosity about the mysterious Miss Mather. Warren in particular, having just left Sotheby's after almost twenty years, confessed her nearly career-long fascination with Mather. Thus, the idea for an exhibition and publication, organized and sponsored by the Santa Barbara Museum of Art, took root almost immediately, but the Margrethe Mather story was a far larger and more complex project than either of us had envisioned. This work concentrates on the dozen or so years during which Mather and Weston were passionate collaborators. (Warren is working on a comprehensive dual biography for future publication.)

Mather and Weston were, by turns, friends, lovers, business partners, helpful colleagues, conspirators, and competitors. Both were profoundly affected by their complex relationship, as the brief remaining fragments of their written memories of each other subtly suggest. Weston burned most of his *Daybook* entries about Mather, and only a few of Mather's heart-wrenching words about Weston remain.

Margrethe Mather's story has been waiting to be told. Fortuitously, three interested parties came together, each essential to the realization of this project. Michael Wilson offered both enthusiasm and his own early research, as well as his important collection of photographs. He had been selectively collecting early Weston material, first becoming particularly intrigued with images of Mather made by Weston, then with images made and signed by both photographers, and, simultaneously, with the prints made by Mather herself. Beth Gates Warren brought both knowledge and considerable research skills to a project that had long been on her wish list, and the Santa Barbara Museum of Art provided the commitment of resources and staff.

Beth Gates Warren perused and researched a vast array of written records and

archives. She interviewed scores of people who had occasionally peripheral, but often essential, information to contribute about Mather. From these sources, Warren has constructed the most complete study of Mather's life to date.

She has also been able to gather several rarely seen images that present compelling evidence of the mutual influence and collaborative spirit at work between the two artists. Her years of research and the support of the Santa Barbara Museum of Art have brought about this book on an important American photographer whose artistry and identity have long been cloaked in mystery.

KAREN SINSHEIMER
Curator of Photography
Santa Barbara Museum of Art

FIGURE 1. Edward Weston, *Margrethe Mather*, ca. 1914, gelatin silver print.
Collection Center for Creative Photography, University of Arizona, Tucson.
© 1981 Center for Creative Photography, Arizona Board of Regents.

"The Late Miss Mather"

PRETEND THAT I DIDN'T EXIST

Margrethe Mather was convinced she would be forgotten; indeed, her own reticence almost guaranteed anonymity. In the autumn of 1950, two years before her death, she wrote a long overdue response to a letter from her old friend the photographer Edward Weston. In it she stubbornly but poignantly resisted the scrutiny of historians by asking him to leave her unremembered. Her words were bittersweet:

It isn't easy, this looking backward from this (my) drab and empty viewpoint to a time that was so rich and so promising. (It is your story)
Several times I tried to write you that it might be sensible just to forget me entirely—to pretend that I didn't exist.
It is very sweet of you to say I "take an important place in those early years" and I appreciate it. However—as a woman their very earliness breaks my heart, and as an ego, annihilate[s] me. You understand—[1]

Weston had contacted her at the beginning of that summer, requesting recollections of their years together, at the suggestion of his friend Nancy Newhall, the photographic historian who was then preparing Weston's journals for publication. Although Weston had destroyed all of his earliest writings covering the years prior to 1923, Newhall had been alerted to his relationship with Mather by a few references in his later diaries. One remark in particular convinced Newhall to delve more deeply, and she urged Weston to renew his old association. He did so. After four months of procrastination, Mather finally replied, and in spite of her obvious reluctance, she continued in her letter to relate the story of how she and Weston had first met. However, typically, she avoided mentioning many of the personal details Newhall must have hoped she would furnish. Weston, in later conversations with Newhall, filled in some of the blanks, but when she finally wrote the introduction to his published *Daybooks*, Newhall was able to say only:

In 1912 or 1913, he met Margrethe Mather, also a photographer. He did not see her at first; to the first casual glance she looked mousy. Then he happened to look at her direct, and was stricken—she was exquisite. It was his first experience of the power of under-statement; he fell in love with art and with Margrethe Mather at the same time, and for some eight years could not separate them. It was a strange and troubling love. She was elusive, disappeared for days where he could not find her, then suddenly on his doorstep would appear a drift of daffodils, with, on paper the delicate grey-green of acacia leaves,

a note of some fifteen words — her attempt at the ancient Japanese poem-form called
haiku. He made her his partner; she was so unpunctual he called her "the late Miss
Mather." He complained that she was often slovenly and dirty, slopping about in men's
shoes. Yet he still loved her, trying to overcome his natural distaste and achieve a height
where "morals" didn't matter. Yet Margrethe with her burning curiosity about what was
happening in art, music, poetry, thought and life brought him what he had never known
before; "art," to him, had been something enclosed in a gold frame on a museum wall or
in magazines on the family's parlor table. He hadn't realized it was happening to him.
Even at the end of his life, he still felt much as he did in the Mexico years — that
Margrethe was "the first important person in my life."[2]

Although this romantic characterization made for tantalizing reading, it gave no
explanation of exactly how and where Mather's and Weston's lives had intersected,
and, furthermore, it left out all evidence that Mather had had her own, very successful
career apart from her affiliation with Weston. Since that time, Weston has become one
of the most renowned photographers of the twentieth century while Mather has
remained one of the most forgotten. The aim of this book and the accompanying exhi-
bition is to remedy that oversight in photographic history, to place Mather's work within
the milieu in which it was created, and to illuminate the working relationship between
Mather and Weston for the first time.

THE FOUNDING OF THE CAMERA PICTORIALISTS

Mather was, most certainly, a photographer before she met Weston. She had joined the
Los Angeles Camera Club by the summer of 1912, and had exhibited at least one of her
photographs in a number of camera club salons in America and Europe throughout the
following year.[3] In the autumn of 1913, during a club outing in Hollywood's Griffith
Park, Mather and a male companion, Elmer Ellsworth, decided to pay an impromptu
visit to a photography studio her friend had noticed on Brand Boulevard in nearby
Tropico (annexed into neighboring Glendale in November 1918). The photographer
received them cordially and introduced himself as Edward Weston.[4]

Mather, Weston, and Ellsworth quickly identified common interests and, in early
1914, Mather proposed that they, together with her young neighbor Arthur S. Little,
and the prominent older photographer Louis Fleckenstein, found their own camera
club. Their club would be for serious camera artists only; it would not cater to amateurs
as most of the other clubs did. Membership would be limited to fifteen people, who
would be admitted purely on the strength of their talent and the intensity of their desire
to expand the boundaries of the medium.[5] Mather's suggestion was appealing to her
colleagues, and in the spring of 1914, the San Francisco–based periodical *Camera Craft*
announced:

Feeling the need of competent criticism and association, a number of the pictorially
ambitious have formed the "Camera Pictorialists of Los Angeles." The membership
is composed of Messrs. Archer, Ellsworth, Fleckenstein, Lindstedt, Little, Monteverde,
Smith, Wallace, Weston, Williams, and Mrs. C. D. Allen and Miss Margarethe [sic]
Mather. Nothing but strictly pictorial work will be done and they hope to add their small
mite towards the advancement of pictorial photography.[6]

The Camera Pictorialists of Los Angeles, which eventually became one of the most important camera clubs and exhibition venues in the country, was Mather's first real contribution to the field of photography. However, after only two years as active members, Mather and Weston abandoned the club, preferring to work in tandem, without the distractions of meetings and internal politics to hamper their progress.

MODEL, MUSE, MISTRESS, MENTOR

Soon after they met, Weston and Mather became romantically involved. It was a furtive affair by necessity because Weston was already married. Mather and Weston were both twenty-seven. Their childhoods had been similar in many respects. Both had been left motherless at a young age and had experienced difficult home circumstances, with foster or stepparents they disliked; both had dropped out of high school due to a lack of interest; both had begun humdrum careers that they gladly jettisoned when they left their hometowns behind and headed for California; and both were finding new direction for their lives, inspired by the satisfaction they were receiving from photography.

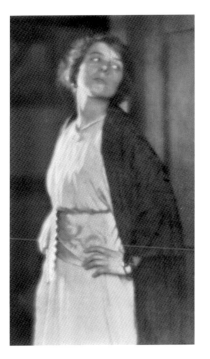

At first Mather and Weston's working relationship evolved along traditional lines—she became Weston's model. One of his earliest successes was with a character portrait casting Mather as the bereaved Empress Carlota, widow of the erstwhile emperor of Mexico, Maximilian, who had been executed by his enemies in 1867 (plate 1). Probably inspired by a novel written by one of Mather's friends, the image was something of a departure for Weston, who had based his reputation thus far on endearingly charming portraits of children and cloyingly sentimental genre scenes.[7] Widely exhibited in salons and reproduced in photographic periodicals throughout 1914 and 1915, *Carlota* garnered significant attention, won several awards, and was Weston's first exhibited image using Mather as subject.[8]

A second collaboration between artist and model, undertaken in 1915, was also well-received. Entitled *Nude with Black Shawl* (plate 3), it was chosen that year for publication in the prestigious annual *Photograms of the Year*, becoming Weston's first

FIGURE 2
Edward Weston, *Margrethe*, 1915, medium unknown, reproduced from *The Camera*, July 1916. Collection Paul Hertzmann and Susan Herzig.

published female nude.[9] Throughout the mid-to-late teens, Mather often sat for Weston, posing for images exhibited and published as *Margrethe (Hand on Hip)*,[10] *The Fan—Margrethe Mather* (plate 4),[11] *Margrethe Mather with Black Vase*,[12] *Margrethe and Plum Blossoms*,[13] as well as for many that were never shared with an audience.

Throughout this period, however, Mather was not simply Weston's lover and muse. She was also his teacher. She influenced his vision and broadened his outlook, artistically and socially. She provided for him a context in which he was exposed to radical new ideas about politics, aesthetics, sexual mores, and life in general. And not only did she parry his every idea with one of her own, she frequently initiated the match. To be sure, she was a consummate foil for Weston's creativity, but, more important, she was a wellspring of inventiveness herself. A meticulous and exacting artist, with an instinctively rigorous sense of proportion and design, she was well known among her artist friends for invoking the axiom, "If it doesn't look right, it isn't right."[14]

REDISCOVERING MARGRETHE MATHER

Until now, the biographical details of Mather's life have remained a mystery. Thanks to an impressionistic memoir written in 1979 by Mather's friend William (Billy) Justema, a few secondhand anecdotes of her adolescence were preserved for the record. However, recent research has now qualified a good deal of the information in Justema's casually recorded, undocumented, and highly readable telling of her story. In fact, it is very possible that Mather herself was responsible for some of the "disinformation" relayed by Justema. Several of her contemporaries later commented on her mysterious comings and goings, her evasiveness, her flightiness—all behavior patterns she hid behind when she did not wish to be held accountable. Indeed, she has remained so successfully elusive throughout the years that historians have never before known that "Margrethe Mather" was not her real name.

She was born Emma Caroline Youngren (variously spelled Younggren, Jungren, Junggren, Youngreen, and Jungreen in assorted historical documents) in Salt Lake City, Utah, on 4 March 1886.[15] Her parents, Gabriel Youngren and his wife, Ane Sophie Laurentzen, were Danish converts to the Mormon faith who had come to Utah in the early 1880s. Ane Sophie bore four children but only two survived childhood, and she, herself, died a week after giving birth to the fourth. Three-year-old Emma Caroline was then sent by her father to live with his deceased wife's sister, Rasmine (Minnie) Laurentzen, also residing in Salt Lake City, where she was employed as the live-in housekeeper for a man named Joseph Cole Mather. Emma Caroline remained with her aunt, under Mather's roof, until she was about twenty years old.[16] Although she spent her childhood as Emma Caroline Youngren, at eighteen she changed her name to Emma Mather and, by the time she arrived in California, she had borrowed her mater-

nal grandmother's given name, becoming Margrethe Mather just in time for the 1910 federal census to record her presence as a roomer in a San Francisco boarding house on the western slope of Nob Hill.[17] In answer to the census-taker's queries, she claimed employment as a manicurist, but Justema believed her profession to have been another, older one — prostitution.

According to Justema, Mather's stint as a prostitute continued after her relocation to Los Angeles, and she may still have been working in that capacity when she first encountered Weston. Her favorite haunts were the lobbies of the posh Alexandria and Lankershim Hotels in downtown Los Angeles, where she would dress demurely, linger over glasses of lemonade, and engage in polite conversation with her male admirers before accompanying them to their well-appointed suites upstairs. Even after she became a photographer, she was not above indulging in illicit liaisons when she needed sudden infusions of cash or a new batch of photographic materials. Several of her friends later recalled that she did whatever she had to do to take care of herself financially, noting that she did not hesitate to trade "favors" with the owner of a nearby photographic supply shop who often spent an afternoon at her studio in exchange for printing paper and film stock. Although lucrative and necessary, these interludes exacted a toll on her self-esteem and made her wary of emotional involvement with the opposite sex. Her lack of discrimination in choosing partners led to many painful experiences, and, unfortunately, her relationship with Edward Weston was in many ways no different from the others.

ANARCHY, LITERATURE, DRAMA

Around 1912, shortly after Mather moved south, she joined the Los Angeles Camera Club on a whim, while in the company of her friend Elmer Ellsworth, also from Salt Lake City.[18] It was Ellsworth who later accompanied her to meet Weston for the first time and who helped her found the Camera Pictorialists,[19] and it's likely he was also the person responsible for introducing her to a circle of eastern European- and Russian-born anarchists, recently transplanted to Los Angeles, who were loyal followers of one of the most famous rabble-rousers in America, "Red Emma" Goldman. Ellsworth, a peripatetic writer, had spent time in New York City, where he became a believer in left-wing political causes and an admirer of Goldman. He would have been only too happy to bring Mather into the fold, and she would have been a willing convert.

The radical rhetoric of her new friends struck a chord with the preternaturally rebellious Mather, who had experienced firsthand the struggles of miners in Utah and their efforts to protect their own interests through the formation of unions.[20] She embraced their philosophies, and, in doing so, her life became filled with prolabor rallies, suffragette meetings, pacifist demonstrations, and bohemian gatherings throughout the

teens. She was not alone. Just as left-wing politics, antiwar demonstrations, and sexual freedom became fashionable during the 1960s among the well-educated, socially conscious avant-garde, the bohemian intelligentsia of the teens rallied around the causes of sexual varietism, the labor struggle, voting rights for women, and pacifism.

Emma Goldman, who made annual trips to California during the early teens, was a powerful force behind the labor movement in that state, and Mather, Ellsworth, and several of their friends actively helped her secure speaking venues and raise funds for her many causes.[21] But, in addition to her prodigious talent as a political activist, Goldman was an aficionado of contemporary literature and theater. Thus, it was also through her connections with Goldman that Mather was introduced to a roster of literary and theatrical people who formed another of her social circles, generally more sophisticated, but sometimes overlapping, with her group of anarchist friends. Many in this second group were writers or actors based in New York, Cape Cod, or Chicago, but they all traveled to the West Coast at one time or another, sometimes hopping a free ride on the freights, frequently appearing on the Chautauqua lecture circuit, occasionally settling in Los Angeles to pursue a career there. As these wanderers journeyed from place to place they brought with them letters of introduction from their network of friends, who requested they be given a congenial reception. In return, they lavished words of encouragement on their struggling California colleagues and circulated news of the latest goings-on in Greenwich Village, Provincetown, and Hyde Park to the bohemian community on Bunker Hill, the buttelike promontory now dubbed "the Montmartre of Los Angeles."[22] And where did Margrethe Mather live but at Bunker Hill's very apex, where she was, quite literally, at the center of such things.

WESTON TURNS BOHEMIAN

Certainly, in that respect, Mather's life represented a stark contrast to Edward Weston's when they first met. In his hometown of Chicago, Weston had led a sheltered, middle-class existence as the grandson of a prominent educator, the son of a well-known physician, and the nephew of a dry-goods salesman at Marshall Field's Department Store.[23] He was anything but a radical thinker. Unschooled in political theory, art history, or current literary trends, he had come to California in 1906, like so many others, with one overriding ambition—he wanted to be famous.[24] Instead, by 1913, he was the disenchanted husband of an older woman who was also his beloved sister's best friend, a harried father of two young sons, a struggling businessman dependent on the largesse of his in-laws, and a resident of Tropico, then a tiny rural community several miles away from the hurly-burly of downtown Los Angeles. He must have sensed that something had gone awry.

When Mather arrived at Weston's front door, she was a completely free spirit and, as such, undoubtedly represented an irresistibly dangerous sexual temptation to him. She was single, beautiful, intelligent, and available. She was sophisticated in matters of heterosexual love but was, by preference, a lesbian.[25] Weston was inexperienced, eager to broaden his horizons, and just beginning to embark on his own sexual voyages. His attraction to her was immediate, but, even in that arena, it would seem Weston was the pupil and Mather the teacher.

Through Mather and her worldly friends, Weston was introduced to radical politics and the artist's lifestyle, and, by 1914, he had begun to reinvent himself, affecting the dress of a fashionable bohemian, donning knickers, a soft blouson shirt, a black four-in-hand tie (the badge of anarchism), and eventually adopting a pince-nez, walking stick, and cape. He started to espouse left-wing philosophies and to speak out against the political maneuverings that inevitably resulted when the vested interests in southern California tried to undermine the formation of local labor unions. Weston also considered himself a pacifist, a stance that would turn dangerous as the European conflicts of the mid-teens erupted into a worldwide war and the American government grew more and more repressive in its efforts to secure an Allied victory.[26]

THE LITTLE TRAMP

About a year after she met Weston, Mather became acquainted with a group of "film folk," then flocking to southern California, each hoping to become the next silent movie sensation at one of the studios popping up all over the perpetually sunny hillsides of Edendale, Hollywood, and Burbank. Through Elmer Ellsworth, she met Keystone Kop Ford Sterling, who in turn introduced them both to a new friend of his, a Cockney vaudevillian with a wicked sense of humor and an extraordinary aptitude for comedic acrobatics.[27] The young man was Charlie Chaplin, newly arrived in Los Angeles to begin work at Mack Sennett's Keystone Studio and about to invent the hapless Little Tramp character that would make him world-famous. Through Chaplin, whose star rose with meteoric rapidity, Mather met an ever-widening circle of talented people — actors, writers, directors, producers. One contact led to another, and many of these creative individuals quickly became Mather's friends. However, taking part in their swanky soirees and high living took a toll on her aspirations, even as it brought a large number of potential portrait sittings to her doorstep. For two years, from 1914 to 1915, Mather was so involved with her new social life that she produced very little photographic work. Then her career got an important boost when she was given the opportunity to open her own photography studio.

When Mather first arrived in Los Angeles she rented a room in a boarding house at 306 South Clay Street, a two-block-long street terraced into Bunker Hill under Angel's Flight, the funicular that ran from Hill and Third Streets up a steep incline to a small park called Angel's Rest on Olive Street.[28] The park, situated directly above a tunnel that burrowed under the hill and carried through traffic to and from the heart of down-town Los Angeles, commanded a panoramic view of the city below. It was a popular spot, and while Mather resided on Clay Street she had ready access to the downtown business district as well as to the Los Angeles Camera Club darkrooms on Hill Street, located almost back-to-back with her boarding house.[29] Still, that convenience did not seem to be motivation enough for her to consider photography a serious career option. She was, according to Justema, content to rely on her physical attractions to cover her living expenses.

All that changed when, around 1916, she moved to much more appealing quarters at 715 West Fourth Street in a carriage house behind an old Victorian home.[30] Perched just below the peak of Bunker Hill, at the northwest corner of Hope and Fourth Streets, it was an ideal location, remote enough to be private but still centrally located. Mather remodeled the carriage house into an open, airy space that doubled as her apartment and photography studio. She covered the wide floorboards with lavender carpet, painted the rough plaster walls and deep moldings white, and added oversize French doors where the carriage entryway had once been. In one corner she enclosed a utilitarian bathroom/kitchen/darkroom area, and along the opposite side of the room she installed a Murphy bed that folded up and disappeared into the wall. The room was sparsely furnished with antique Japanese and Chinese pieces that she frequently used as props in her portraits, and scattered about were a few split-bamboo chairs and hourglass stools. A deck overlooked a verdant hillside covered with trailing vines and punctuated with eucalyptus trees before it ended abruptly in a precipice leading to Flower Street below.[31] Her studio was modest, but it was the first place she could call her own, and it became her anchor through the coming years.

It was generally known among her friends that an admirer had secured her lease there, and, according to Justema, that admirer was Mather's lesbian lover, a woman he referred to only as "Beau."[32] The woman became her mentor and protector at the same time that Mather was involved with Emma Goldman's friends, and it is very likely that "Beau" was a part of Goldman's circle. She may have been Florence Reynolds, an acquaintance of Goldman's from Chicago, who regularly traveled to Los Angeles dur-ing the mid-teens to visit her sister and brother-in-law in Hollywood.[33] Reynolds was an associate and benefactress of Margaret Anderson and Jane Heap, publishers and editors of Chicago's famed literary magazine *The Little Review*. Anderson and Heap were

both intimates of Goldman's, and, when they brought *The Little Review* briefly to California in 1916, Mather held a fund-raising event at her new studio in their honor and, subsequently, became well acquainted with many of the magazine's contributors. If Florence Reynolds was Mather's mysterious mentor, Justema's recollection of her as "Beau" was either a faulty remembrance or an intentionally oblique pun, because Reynolds's nickname was "Ho," not "Beau." However, she would have enjoyed the joke because she was an inveterate "hobo" herself, vagabonding from place to place throughout her life. When their relationship ended, "Beau" discreetly disappeared, but not before she had arranged for a lifetime lease to the carriage house in Mather's name.

MARGRETHE MATHER, PHOTOGRAPHER

The same year Mather moved to her West Fourth Street studio, she began to advertise herself as a photographer, and she continued to do so throughout her years of affiliation with Weston.[34] Although many details of Mather's early Los Angeles life have recently come to light, information about her pre-1916 photographs remains frustratingly scarce. Two of her images were reproduced in periodicals, one in 1913[35] and one in 1916.[36] Two portraits from 1915 were recently discovered inside a scrapbook belonging to the son of one of her friends.[37] Salon exhibition catalogues reveal the title of another image that does not seem to exist today, even in reproduction.[38] However, beginning with her work from 1916, a number of original prints and reproductions remain to document Mather's artistic evolution.

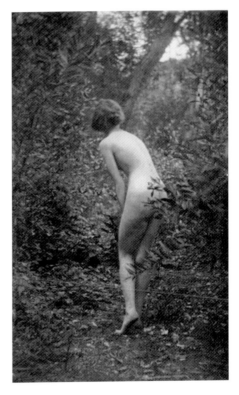

Her first known image, reproduced in the January 1913 issue of *American Photography*, was titled *Maid of Arcady*, and it depicted a female nude in a sylvan setting with her back to the viewer, her derriere modestly screened by a leafy branch.[39] Although composed in the fashion of the time and classically titled, it was a daring photograph for 1912 because it had been taken by a woman. The model remains unidentified, but it very possibly was Mather herself. She entered the photograph in the Ninth American Salon, which opened at the Carnegie Institute in Pittsburgh in November 1912 and traveled throughout the spring to Portland, Maine, and the Art Institute of Chicago.[40] The photograph also was included in a salon in Ghent, Belgium, later that same year.[41]

Mather's two earliest extant photographs, dated "1915" on the scrapbook page where they are still mounted, were taken shortly before she moved into her new studio.

FIGURE 3
Margrethe Mather, *Maid of Arcady*, 1912, medium unknown, reproduced from *American Photography*, January 1913. Collection Paul Hertzmann and Susan Herzig.

They are both portraits of an appealing young man named Russell Coryell.[42] A Harvard dropout who had come to California looking for adventure, Coryell was the son of two of Emma Goldman's closest associates. Two more portraits, taken after Mather's move, were of her friends Maud Emily Taylor (plate 6) and Mollie Price Cook (plate 5), also

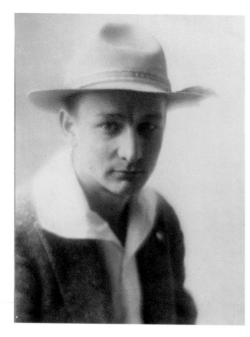

FIGURE 4
Margrethe Mather,
Russell Coryell, 1915,
platinum/palladium
print. Collection
Mr. and Mrs.
Stanis Coryell.

members of the anarchist/bohemian community in which Mather circulated. Taylor, a young woman newly arrived from Texas, had come to Los Angeles to study acting and writing.[43] The Chicago-born Cook had spent time in New York working as a journalist on Emma Goldman's magazine *Mother Earth* and, following a failed marriage, she had relocated to California to open what may have been the first Montessori school in Los Angeles.[44] She employed Taylor, both as an aide at the school and as a live-in au pair for her own two children. Both women became friendly with Mather and Russell Coryell. In portraits of her two women friends, made circa 1916, Mather was still working in the traditional pictorialist vein, employing a soft-focus lens to give the images a gauzy, romantic quality. It is worth noting that both images featured discernible shadows, integrated as subtle textural and compositional elements. Within a short time, both Mather and Weston would begin to use shadows in a much more defined way to add interest and strength to their portraits.

In November 1916, a photograph by Mather entitled *The Stairway* was reproduced in *American Photography*.[45] Mather's artistic progress was immediately evident. In this image she dramatically compressed space, creating deep shadows in a diagonal swath across half of the image, and capturing reflected light as it bounced off a syncopated progression of stair steps leading up to a female figure (probably Maud Emily Taylor) who stands at the very top and center of the composition, her open parasol brightly lit and her face hidden in deep shadow. More sophisticated than her earlier attempts, it was undoubtedly influenced by the conventions of the Japanese woodblock and Professor Arthur Wesley Dow's famous book *Composition*, which was based on the Japanese concept of *notan*, an aesthetic system, widely popular at the time, for arranging light and dark areas within a design scheme.[46]

In another image of Taylor, Mather created a beautifully subtle, white-on-white

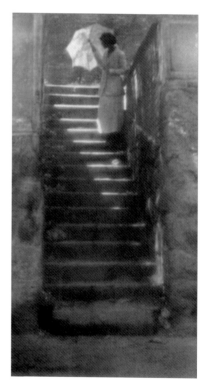

FIGURE 5
Margrethe Mather,
The Stairway, 1916,
medium unknown,
reproduced from
American Photography, November
1916. Collection
Paul Hertzmann
and Susan Herzig.

confection that was a tour de force of printing technique and stylistically reminiscent of the tonal paintings of James Abbott McNeill Whistler (plate 7). Indeed, both Mather and Weston were influenced by the substantial revival of interest in that much-revered nineteenth-century painter's work then taking place in artistic circles.[47] This image became Mather's first important success, reproduced under the title *Miss Maud Emily* in the 1917–18 volume of *Photograms of the Year*.[48]

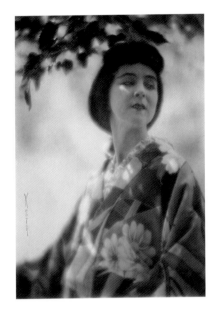

FIGURE 6
Edward Weston,
Ruth St. Denis, 1916,
platinum/palladium
print. Courtesy
George Eastman
House.

Around this same time, Mather began her series of portraits of people affiliated with Chicago's *The Little Review*, a magazine she probably introduced to Weston, who is known to have read it religiously during this period. In 1916 and 1917 she photographed the poets Alfred Kreymborg (plate 11) and Billy Saphier, writer Harriet Dean, actor Frayne Williams (plates 9, 10) and oil heiress Aline Barnsdall, all of whom had some direct or indirect connection with that publication.[49]

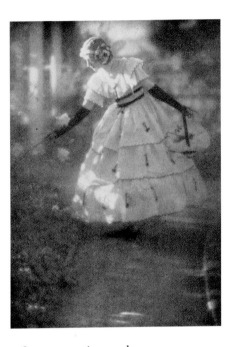

Meanwhile, Weston was busily photographing the dancers of Los Angeles, a subject that had become his new specialty and one he may have owed to Mather's contacts in movie and theatrical circles. From late 1915 until mid-1917 most of the images Weston submitted to salons or for publication were either his typical portraits of children or studies of modern dancers. Characterized as "high-key" pictures, they were photographed with a soft-focus lens and lighting that created a kind of chiaroscuro effect, with an abundance of twinkling highlights. Although these photographs are far too sentimental to appeal to today's viewer, they were extremely well received at the time, and Weston unabashedly played to his audience, creating image after image in this vein. It was not until early 1917 that Weston began to exhibit photographs that demonstrated a dramatic shift in style.

FIGURE 7
Edward Weston,
Sunbeams [Violet
Romer], 1915,
medium unknown,
reproduced from
American Photography,
December 1918.
Private Collection.

THE SHADOW PICTURES

Perhaps this change came, at least in part, because of a cross-country trip Weston had taken during the summer of 1916, when he had been invited to give a demonstration in printing technique at the Professional Photographer's Association convention in Cleveland.[50] Travel was a lifelong stimulant to Weston, and he usually returned home full of new ideas; this jaunt proved no exception. On his way back to California, he stopped

off in Chicago to visit his relatives and, probably at Mather's suggestion, went to see the photographer Eugene Hutchinson, whose studio was in the Fine Arts Building on Michigan Avenue, also home to the offices of Margaret Anderson's *The Little Review*. Hutchinson was, himself, well on his way to building a reputation as a fine portrait photographer. He had already photographed Mather's friends Anderson and Emma Goldman, and his photograph of the late poet Rupert Brooke was the only one that, thus far, had been reproduced in *The Little Review*.[51]

When Weston made Hutchinson's portrait (plate 8), he attempted something startlingly different, solidifying Hutchinson's shadow into an expressive caricature of the man himself and organizing the background into flat planes of light and dark.[52] While Mather seems to have been the one to first understand the potential in employing shadows to add dimension and design to portraits and figure studies, Weston was the first to allow the shadows to dominate as a highly effective, dramatic device. Weston followed up his portrait of Hutchinson with other strong images, including a portrait of the California heiress Dextra Baldwin, in which he borrowed his striated lighting effects from Mather's *The Stairway*;[53] a study of the *Los Angeles Times* art critic Antony Anderson;[54] and one of Weston's elderly father, modeled after Whistler's famous depiction of maternal devotion[55]—all of which were published and exhibited widely in 1917.

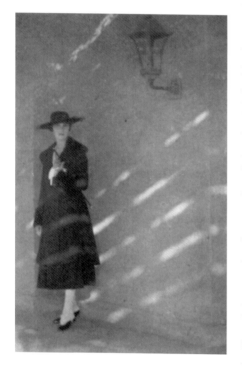

While Weston evolved his style of incorporating shadows as compositional elements, Mather worked out her own approach. Her portrait of the poet Alfred Kreymborg (plate 11) was done in the early summer of 1917, when he was in Los Angeles on his first cross-country lecture tour.[56] In it, Mather began to formalize her use of shadows to produce a stark image of considerable intensity. She utilized similar compositional devices in images of her actor friend, the Welshman Frayne Williams (plates 9, 10), as he portrayed various characters from his stage performances at Aline Barnsdall's newly founded Little Theatre in Los Angeles.[57] (Barnsdall, a friend of both Emma Goldman and Margaret Anderson, had named her company after the original Little Theatre in Chicago, also located in the Fine Arts Building, where she had first been inspired to form her own dramatic troupe.)[58] Probably thanks to Mather's friendship with Chaplin, she also photographed the silent screen star Lillian Gish, as well as Russian dancer Vaslav Nijinsky and set and costume designer Leon Bakst when Serge Diaghilev's famed Ballet Russe made its Los Angeles debut that same year. Unfortunately, examples from these last three sittings remain unlocated to this day.[59]

Around 1918, Mather made several more studies of her women friends. On one occasion she depicted Maud Emily Taylor gazing intently at the camera, wearing a dark dress and a Navajo squash blossom necklace (plate 12). In another sitting, Mather portrayed Taylor, head bowed, seated in a Chinese chair in front of a low table adorned only with a black vase containing a bare branch (plate 13). Mather also made a portrait of a vivid new person in her life, a young Rumanian émigré and labor organizer named Betty Katz, posed in profile against a Roman window shade, holding a single long-stemmed rose (plate 14).[60]

Although all of these portraits were taken in Mather's West Fourth Street studio, she had begun regularly working with Weston in Tropico at least by February 1918.[61] It was then that Weston and Mather first met Johan Hagemeyer. The Dutchman Hagemeyer was interested in studying photography and had come to Weston's studio on the advice of friends. The three quickly became comrades, and in the spring of 1918 Hagemeyer moved for a few weeks into Weston's home while he "apprenticed" with Weston at the studio.[62] Hagemeyer, like Mather, held to the anarchist philosophy, and the three friends talked freely about photography, politics, art, and music whenever they were together. After only three months, however, Weston anxiously asked the outspoken Hagemeyer to leave his home. Hagemeyer's political affiliations were beginning to pose a risk to Weston's family, especially in light of the Espionage Act of 1917 and the Sedition Act, passed in the spring of 1918, which made it a crime to criticize the United States government's involvement in World War I.[63] Hagemeyer moved on to San Francisco in early 1919 and then finally fled the country for a few months in 1920 during the Red Scare.[64] He and Weston continued corresponding throughout this period, and, in his letters, Weston made many veiled references to the political climate and the effect it was having on all of their lives.

Shortly after Hagemeyer moved north, Weston and Mather befriended a young, mystically inclined intellectual, Clarence B. (Ramiel) McGehee. McGehee, who lived in an apartment behind his sister's small house in Redondo Beach, was a scholar of oriental art and philosophy, and occasionally gave esoteric demonstrations in classical Japanese dance. He became very intimate with Weston, and, for a brief time, they had a physical relationship, later termed an "experiment" by Weston.[65] McGehee also grew close to Mather and Betty Katz during this period, and the four friends spent many hours together, enjoying the nightclubs and other popular watering holes of downtown Los Angeles.

THE MOON KWAN PICTURES

Around mid-1918 Mather made a striking refinement in her style when she embarked on a series of portraits of another of her friends, the Chinese poet Moon Kwan. These

portraits appeared deceptively simple, but, because of their sheer simplicity, each element had to be perfectly placed. There was no room for error and Mather finessed their execution flawlessly. She was extraordinarily bold in her exclusion of detail, unafraid to use empty space and lush, modulated tonalities to satisfy the viewer's senses rather than relying on a plethora of detail. One image of Moon Kwan, titled *The Chinese Flute*, was first exhibited in the autumn of 1918.[66] Mather photographed her subject in profile, leaning his body back toward the left edge of the picture plane, with a batonlike object resting in the crook of his right arm at waist level. His shadow filled the center of the image, forming an enlarged, amorphous shape that was less expressive than

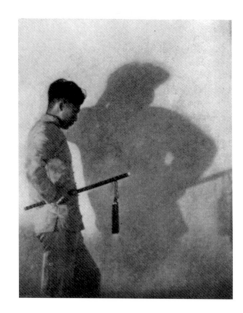

FIGURE 9
Margrethe Mather, *The Chinese Flute*, 1918, platinum/palladium print, reproduced from *Camera Craft*, 1919. Collection Paul Hertzmann and Susan Herzig.

abstract. In *Player on the Yit-Kim* she further simplified her composition (plate 15). Moon Kwan was positioned in the lower-left corner, holding a mandolin-like stringed instrument, his figure balanced by a calligraphic scroll hanging from the upper right. *Portrait of Moon Kwan*, exhibited along with four other images in the renowned Pittsburgh Salon of 1919, was even more daring.[67] Truncating her sitter's body at shoulder level, while counterbalancing his triangular solidity with an unfurled Chinese figural scroll, Mather relied on an area of dense shadow in the upper-right corner to achieve equilibrium. Although today it is difficult to understand what a radical departure this image represented, when it was reproduced in the September 1919 issue of *American Photography*, the reviewer wrote:

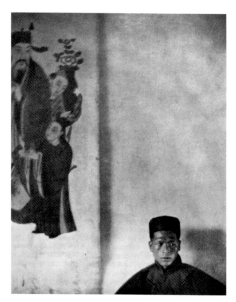

FIGURE 10
Margrethe Mather, *Portrait of Moon Kwan*, ca. 1918, platinum/palladium print. Reproduced from *American Photography*, September 1919. Collection Paul Hertzmann and Susan Herzig.

> *"Portrait of Moon Kwan," by Margrethe Mather, is an experiment in composition which is probably based on some Oriental model. The balance between the three dark spots seems to be carefully worked out, and undoubtedly has a sound logical basis. The appreciation of this form of composition however, is at present with the writer purely an intellectual one, like that of some of the newer forms in music and painting. Presumably the next generation will accept arrangements like this instinctively. Such is the way in which art grows.*[68]

Indeed, Mather was already far ahead of the critics, and of Weston. Her Moon Kwan series was of great significance within her body of work and the history of photography. Not only did she present her Chinese sitter with dignity and sensitivity—unlike most of her contemporaries, who were still relying on patronizing, racial stereo-

types—but her images were daringly original, precisely composed, and startlingly spare, with few precedents or parallels in the history of the medium. Margrethe Mather hit her stride with the Moon Kwan photographs more than a year before Weston began his attic pictures, a series that would become as important a benchmark in his professional development as Mather's Moon Kwan portraits were in hers. However, before Weston began the attic series, he made two very memorable transitional images, and this time Mather was his model—in every sense of the word.

ON THE BRINK OF MODERNITY

Taken by Weston near the end of 1919, *Epilogue* and *Prologue to a Sad Spring* were not portraits. More accurately, they were figure studies in which Mather's face and form were subordinated to the design of the overall composition. Weston employed the elements of clothing, makeup, hairstyle, pose, and expression to create a mood rather than to elucidate a specific personality. Made on the cusp of the second and third decades of the century, the two images visually exemplified the dramatically differing artistic sensibilities that characterized the two eras, a sea change in taste that Weston undoubtedly sensed and set out to capture on film.

Although probably taken first,[69] *Epilogue* was the more modern of the two images, combining aspects of his experimental shadow pictures from the mid-teens with the geometrical planes and massings that began to dominate his images in the early twenties (plate 17). In *Prologue to a Sad Spring*, Weston reverted to a more realistic romanticism, employing the expressionistic shape of the tree's shadow as an important aspect of the composition, but allowing Mather's facial features (and his own title) to set the tone and guide the viewer's interpretation of the image (plate 18). Predictably, the critics loved the narrative *Prologue to a Sad Spring*, but when the more stylized *Epilogue* was reproduced on the cover of the August 1920 issue of *Photo-Era*, the reviewer irritably called it "capricious design" and suggested that the viewer should "decide for himself the significance" of the picture, while warning that it would require a "fertile imagination" to do so.[70] This was rare negative criticism for Weston, and he must have realized that to go further down the path of experimentation would almost certainly mean losing the audience he had worked so hard to gain. Consequently, he remained torn between competing visions, as he teetered back and forth on the brink of modernism for the next several months.

During this period, Mather became entwined in the life of two new individuals. One was a handsome, Irish-born anarchist, another of Emma Goldman's friends, who had earned the sobriquet "Wild Joe" O'Carroll when he made the headlines of the *New York Times* in 1914 for leading a demonstration of homeless men at Cooper Union and being severely beaten by the police in the melee that ensued.[71] O'Carroll had come to California in the mid-teens to organize workers in the oil fields and, perhaps, to wreak some violence on behalf of the labor movement there. He was a bombastic fellow with a reputation for ferocity and a gift for rhetoric. The intensity of his personality is plainly evident in the portrait Mather made of him while they were lovers (plate 19). Both Weston and Hagemeyer also knew O'Carroll well, and Weston came to fear and detest him, as he made clear in several letters to Hagemeyer.[72] Whether Weston's intense dislike of O'Carroll was because of the danger he represented or because of the place he occupied in Mather's affections cannot be wholly discerned from Weston's comments.

Then in the fall of 1919, just as O'Carroll was about to depart Los Angeles for Bakersfield, Mather met a beautiful young actress named Florence Deshon. Deshon was the girlfriend of Max Eastman, the former editor of the socialist periodical *The Masses*, who has been characterized as the "Byron of the left" because of his dashing good looks.[73] Deshon had arrived in California during the summer of 1919 after already enjoying considerable success in New York as an advertising model and stage actress, and appearing in two films produced there. She had come west determined to try her luck in Hollywood, and Charlie Chaplin, who had become acquainted with Max Eastman the previous year when Eastman was in Los Angeles to deliver a series of lectures, grew intent on helping her succeed. Mather and Chaplin quickly became Deshon's closest friends in California, and both began to court her. Mather photographed Deshon, gave her gifts for her new apartment, rescued her when she was in trouble, took care of her when she was ill, introduced her to Weston, Ramiel McGehee, Frayne Williams, Reginald Pole, Moon Kwan, and Betty Katz, and moved in with her for days at a time.[74] No proof exists that Mather and Deshon became lovers, but circumstantial evidence suggests they did. Based on what still exists of her work today, Mather seems to have made more photographs of Deshon than of any other sitter, including Weston, and, perhaps most tellingly, she never exhibited any of these portraits, preferring to keep her admiration and their relationship private (plates 20, 21, 52, 53, 54, 55).

Mather's photographic successes continued when in March 1920 four of her images were selected for inclusion in the annual Pittsburgh Salon.[75] Two of these photographs, titled *Pointed Pines* (plate 22) and *Black Acacia*, were her first exhibited still life subjects.

Soon thereafter she was notified that in "recognition of [her] consistently high grade of pictorial work, exhibited at the Pittsburgh Salon," she was being named a Contributing Member in that illustrious organization.[76] It was one of the highest honors any photographer could receive, and Mather was one of a handful of women ever to achieve it. During this same period she also had her first one-woman exhibition in Boston,[77] and was represented in the selective and prestigious Wanamaker Salon in Philadelphia[78] and the Frederick & Nelson Salon in Seattle.[79]

THE ATTIC PICTURES

While Mather was enjoying these professional successes and continuing her immersion in Florence Deshon's life, Weston became involved with two women who would change his. The first was Mather's old friend Betty Katz. During the summer of 1920 Weston embarked on what are now known as his attic pictures. The first image from this series was a study of Ramiel McGehee in his garret apartment in Redondo Beach taken that July. In

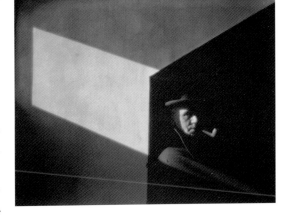

October Weston entered into an ardent but brief love affair with Betty Katz and made a series of images of Katz in her attic aerie on North Broadway.[80] One, in particular, titled *Betty in Her Attic* (plate 27), was paired with *Ramiel in His Attic* (plate 28) when Weston sent them to several exhibitions during 1921.[81] Both images conveyed the sitters' individuality, but Weston utilized the acute angles of the attic dormers to create geometrical, receding or advancing planes of light and dark that became the real subject of the photographs. Weston followed these with *Ascent of Attic Angles*,[82] another image of Katz, and *Sunny Corner in an Attic*,[83] an image of Johan Hagemeyer. Made in McGehee's beach house, these compositions were even more stark and angular, and the sitters virtually unrecognizable, their physical characteristics simplified to either a stylized silhouette or an abstracted mask.

Around the end of 1920 Mather countered with a series of even more elegantly pared-down images of her Danish-born actor friend Otto Matiesen in white stage makeup and neck ruff, portraying the classic French pantomime character Pierrot.[84] By viewing two variants of these pictures side by side we can see Mather's ruthlessly reductive eye at work. In one she included a tassel hanging from the upper-left corner in opposition to the figure of Pierrot, placed low in the right corner and cropped at the shoulders in a composition similar to *Portrait of Moon Kwan* (plate 29). In the other she eliminated the tassel entirely and relied instead on a dense shadow stretching across the bottom to anchor the picture, balanced by a lighter wash of shadow extending up the left edge (plate 30). More than three-quarters of the image was left empty. The astoundingly self-assured result was proof of her truly fearless editing genius.

Mather depicted a second clown-figure around that same time, a delightful portrait of a marionette (plate 31), possibly one used by the poet Alfred Kreymborg when he returned to California during the second half of 1920 to present a series of "puppet plays," which he and his wife, Dorothy Bloom, performed at several venues in Los Angeles and San Francisco.[85] It was this image that undoubtedly served as the inspiration for Tina Modotti's studies of a similar subject in 1929.[86]

Other exceptional images of that year were her portraits of Frayne Williams in trench coat and hat, as he appeared in Arthur Schnitzler's play *Anatol* (plate 32),[87] and Reginald Pole enacting the role of Othello (plate 33).[88] Mather also photographed the Irishman Charles Gerrard, an actor trained on the Dublin stage, as the urbane man-about-town, resplendent in waxed mustache and brandishing a cigarette holder (plate 34). And she posed a woman, identified only as "Judith," with her back to the camera, holding a fur wrap, her hair coiffed in a chignon above a gracefully bared neck (plate 35); on the wall behind the elegant woman, Mather hung a framed photograph.[89]

MATHER AND WESTON, CONTRARIANS

Both Mather's *Pierrot* and Weston's *Betty in Her Attic* were selected for reproduction in *Photograms of the Year* but, not surprisingly, the bewildered reviewer dismissed both photographs as stunts:

> *I fear some such notion of "pure cussedness" prompted the idea in M. Mather's "Pierrot" (XXVIII), whilst queerness for its own sake must have obsessed Edward Weston when he recorded the stiff and angular lines in "Betty in Her Attic" (XXIX), although there is no denying the truth and beauty too of tones of the floor and walls. But the position of the girl!—is there not a touch of pure cussedness in that?* [90]

These words betrayed the dearth of intelligent, insightful criticism then common in the photographic salon world. If Mather and Weston had chosen to continue working in their former, more traditional styles, they surely would have enjoyed several more years of popular success. Instead, they soon turned their backs on the salons entirely and went their own way.

During the summer of 1920 Weston traveled to San Francisco for a last week of gaiety before Johan Hagemeyer slipped away to Europe for a few months. While in the Bay Area, Weston met a number of local photographers and artists for the first time. Imogen Cunningham, Roi Partridge, Dorothea Lange, Maynard Dixon, Anne Brigman, and Helen MacGregor all joined in welcoming Weston to their turf, and, while he was in their company, Weston first began to talk of moving away from California to some other, as yet undecided, location. Soon after he returned to Los Angeles he sent a group of his photographs to Cunningham via Hagemeyer; also included in the package was a selection of images by Mather. Cunningham responded favorably to them all, but she demonstrated the depth of her appreciation for Mather's work, in particular, when she wrote:

She expresses a charming self in her work and a niceness in printing which just makes me grieve that I cannot have a piece of raw platinum in my hand. . . . Since seeing the work of you two I feel, when I let myself think about it, as if I had a stone in my stomach and my hands tied behind my back.[91]

THE FORMAL PARTNERSHIP

The year 1921 brought a change in both the personal and professional relationship between Mather and Weston. Although the intensity of their initial attraction had long since ebbed, Mather and Weston had enjoyed a mutually affectionate relationship for eight years and they still

FIGURE 13
Edward Weston, *Tina Modotti in Batik Gown*, 1921, platinum/palladium print. Collection Center for Creative Photography, University of Arizona, Tucson. © 1981 Center for Creative Photography, Arizona Board of Regents.

depended a great deal on each other for emotional support. However, around the same time that his brief fling with Betty Katz was coming to an end, Weston met Tina Modotti. Then twenty-four, Modotti was an Italian-born beauty who had emigrated to America in 1913, begun a career on the stage in San Francisco's *teatro Italiano*, become involved with a flamboyant artist who called himself Robo l'Abrie de Richey, and moved with him to Los Angeles in late 1918. In the spring of 1921 Weston began to photograph her, and that overture soon led to intimacy, just as it had with Mather and would with so many others. This time he was thoroughly absorbed in his new love affair.[92]

Shortly after Weston began his relationship with Modotti, he and Mather came to a new understanding—the two photographers agreed to be equal partners. Although there are no references to this arrangement in any of Weston's surviving papers, approximately a dozen photographs exist, all dated "1921," which are signed with both Mather's and Weston's names. This is notable because it was the only time during Weston's career that he ever co-signed work with another photographer, and we can only speculate about his motivations in entering into such an arrangement with Mather. However, it seems highly likely that Mather's newly elevated status was accorded her by Weston out of respect for her recent accomplishments and recognition, because he felt guilty over the time and attention he was lavishing on Modotti, or because Mather demanded some formal acknowledgment of her contribution to the success of his portrait business.

Together, he and Mather signed portraits of the poet Carl Sandburg (plate 36), the publisher and author Max Eastman (plates 37, 38, 39, 40), the painter Gjura Stojana (plate 43), and the Marion Morgan dance troupe (plates 41, 42). These pictures were exhibited as joint efforts on several occasions that year, with one reviewer referring to the two photographers as an "art partnership."[93] The images of Eastman were particularly important as presentiments of Weston's later fascination with the abstract rhythms of sand and sea. Curiously, Eastman, in his autobiography, recalled very clearly that these portraits had been taken by Mather, not Weston, even though the photographs themselves had been signed with both names.[94] An examination of this small group of doubly signed pictures suggests that either the two names were signed by the same hand, or that Mather and Weston were so professionally synchronized by 1921 that they had adopted a very similar calligraphic style.

Mather and Weston also continued to make photographs independently that year. Weston concentrated on sensual portraits of Modotti (plate 45) and made important studies of a man wearing a Japanese fighting mask (plate 44), as well as portraits of Johan Hagemeyer, the young Theosophist Sibyl Brainerd, the Mexican art critic Ricardo Gómez Robelo, and Modotti's lover, Robo de Richey. Mather created a double portrait of Weston and Hagemeyer that endures as one of her masterpieces, alongside her Moon Kwan and Pierrot pictures (plate 46). In it she placed Hagemeyer on the left, wearing his characteristic billed cap and smoking his ever-present pipe, while Weston was positioned on the right, captured in slightly softer focus. Each subject's face was cropped so as to reveal only eyes, nose, and mouth, with their profiles defined by the solidity of the negative space between them. The image stands as one of the most provocative renderings in all of photographic portraiture, conveying the affection, as well as the wariness, that existed between the two photographers. Perhaps only someone who knew both men as thoroughly as Mather did could so skillfully have portrayed the complexities of their relationship.

She also made several portraits of Weston alone, posing in front of a painting, enveloped in Hagemeyer's cape, and standing on a staircase (plates 48, 49, 50). Then she brought her camera up close, filling the viewfinder with Weston's features, so that his face appeared almost lifesize in the final print, another radical departure from conventional portraiture of the day (plate 51). That approach would be one she would use several times during the early twenties, portraying the human face as a psychological map, with its swells and shallows and curves, emphasized by somber shadows, broad washes of light, and unconventional cropping, to reveal the topography of the individual's personality.

THE END OF AN ERA

The spring of 1922 was a time of soul-searching and unexpected sorrow for Mather, Modotti, and Weston. When Florence Deshon's career had come to a standstill during the summer of 1921, shortly after her relationship with Chaplin ended, she had decided to return to New York, hoping to resume her love affair with Eastman and find work through her old theatrical contacts. Things did not go as planned, however, and in February 1922, a few weeks after her return to the east, Deshon was found unconscious in her gas-filled Greenwich Village apartment. She

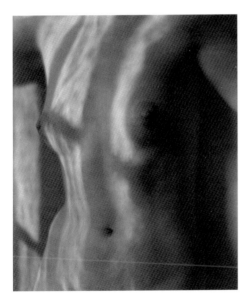

was rushed to nearby St. Vincent's Hospital but perished a few hours later, an apparent suicide.[95] Mather fell into a deep depression on hearing the sad news.[96] That same

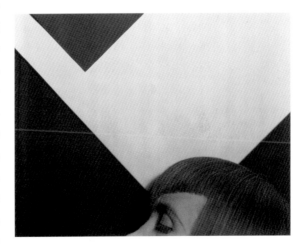

month Tina Modotti learned that Robo de Richey, who had left on an exploratory trip to Mexico the previous December, had died unexpectedly after a very brief illness, and, just a few weeks later, the tragedy of de Richey's demise was exacerbated by the death of her father.[97] Weston, who also considered Deshon and de Richey his friends, suffered from these losses as well.[98]

However, by the summer Weston not only had recovered but seemed newly invigorated, making a pair of nude studies of an unidentified female model that rank among his best works, as well as a stark, angular study of the pianist Ruth Deardorff Shaw

FIGURE 14
Edward Weston, *Refracted Sunlight on Torso*, 1922, platinum/palladium print. Collection The Museum of Modern Art. © 1981 Center for Creative Photography, Arizona Board of Regents.

FIGURE 15
Edward Weston, *Ruth* [Deardorff] *Shaw*, 1922, gelatin silver print. Courtesy George Eastman House.

and portraits of his old friend Ramiel McGehee; his new neighbor, the artist Peter Krasnow; and photographer-turned-cinematographer Karl Struss. Weston also produced several sinuous nude studies of his third son Neil, a subject he would revisit three years later in his earliest experiments with abstracting the human form. Throughout the summer months he formulated his plan of action, vowing to leave for Mexico as soon as he could put certain professional matters in order. Mather, on the other hand, remained distraught and saddened, and participated in only a handful of exhibitions that year.[99] Two of her images, shown in 1922, were a still life, *Water Lily* (plate 66), and a portrait, *Dr. William F. Mack, Roentgenologist* (plate 59). It was no coincidence that Dr. Mack was the brother-in-law of Florence Reynolds, the woman who most likely had acted as Mather's mentor a few years earlier.[100]

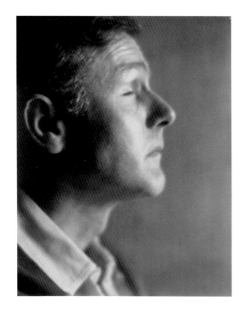

FIGURE 16
Edward Weston, *Blind* [Ramiel McGehee], 1922, gelatin silver print. Collection Center for Creative Photography, University of Arizona, Tucson. © 1981 Center for Creative Photography, Arizona Board of Regents.

That same summer Mather and Weston were photographed by Imogen Cunningham in the only series of images ever made of the two of them together. In July Cunningham and her husband, the artist Roi Partridge, briefly visited Los Angeles as guests in Weston's home (plates 56, 61).[101] One day Cunningham joined Weston and Mather at the Glendale studio where she exposed several negatives of them (frontispiece, plate 62). She later commented that she was especially pleased with one variant because of the "*stimmung,*" or feeling, it conveyed about their relationship.[102] Even though the two women never knew each other well, Cunningham remained mightily impressed by Mather's talent and continued to champion her work for many years.

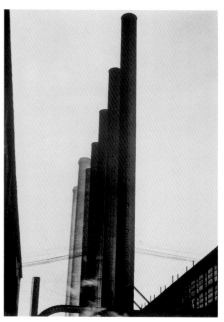

FIGURE 17
Edward Weston, *Armco Steel, Ohio,* 1922, gelatin silver print. Collection Center for Creative Photography, University of Arizona, Tucson. © 1981 Center for Creative Photography, Arizona Board of Regents.

In anticipation of his imminent departure for Mexico, Weston set off in the autumn of 1922 on a cross-country trip to visit his sister in Middletown, Ohio, where he made his famous photographs of the nearby Armco Steel plant. From Ohio he continued on to New York where he met Alfred Stieglitz, Georgia O'Keeffe, Paul Strand, Charles Sheeler, Clarence White, and Gertrude Kasebier. It was a life-changing experience, and Weston returned to California more determined than ever to leave the demands of his family and studio behind in order to seek new artistic inspiration with Modotti.

Throughout the first half of 1923 Weston and Modotti kept postponing their Mexican sojourn. Ironically, most of the photographs made by Weston that spring were

of Margrethe Mather. A series of nudes were among his final images of her taken in the Glendale studio. Clad only in embroidered Chinese slippers, Mather stood or sat in front of a silvery, paneled screen with just a few simple props to interrupt the reflective expanse behind her (plates 63, 64, 65). From assorted combinations of these elements, Weston created a radiant series of visual exercises in rhythm and light, incorporating Mather's figure as the focal point and composing the image around her. One variant so closely resembled Mather's own photograph of Maud Emily Taylor we can only conclude that either Weston set out to intentionally reference Mather's earlier image or that she acted as stylist for his (plates 13, 64).

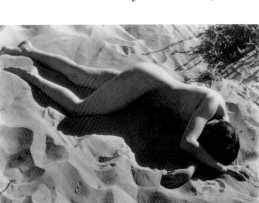

Then, shortly before his departure at the end of July, Weston spent a few days in Redondo Beach with Mather and McGehee and revived his old love affair with Mather during what he would later call "that last terrific week with her, before leaving for Mexico."[103] Together they produced an astonishing series of images of Mather lying nude on the beach. These pictures were sharply focused, capturing every pore of skin, every strand of hair, and every grain of sand in a kind of hyperrealism that was explicitly erotic and very unlike Weston's idealized nudes from previous years (plate 67). Almost certainly he dared make them because of the intimate portraits of Georgia O'Keeffe he had so recently viewed at Stieglitz's gallery. These pictures of Mather became Weston's best-selling photographs whenever he exhibited them in Mexico, constantly reminding him of the woman he had left behind and their history of collaborative success.[104] Weston later recalled that the painter Diego Rivera liked "one of the beach fragments of her [Mather] the best of anything in my collection," saying, "This is what some of us 'moderns' were trying to do when we sprinkled real sand on our paintings or stuck on pieces of lace or paper or other bits of realism."[105] These studies, the last Weston would ever make of Mather, became the prototypes for the nudes he would take of his young lover (and soon-to-be second wife) Charis Wilson, languorously stretched out on the dunes of Oceano, some thirteen years later.

After Weston left, Mather continued working at the Glendale studio for a year and a half, replacing his sign with her own and taking on new portrait business. But around 1920 Weston's wife, Flora, had inherited the studio property from her deceased mother,[106] and a few months after Weston departed, an embittered Flora resolved that Mather would not remain. Apparently intending to take advantage of Weston's absence, Flora's sister's husband,

FIGURE 21
Margrethe Mather,
*Leta Bessie Squires
with Parasol*, ca. 1923,
platinum/palladium
print. Collection
Sandra Pitts.

Edward Ellias, decided to open his own photography studio in Glendale, and it was likely at his behest that the long-suffering Flora began her campaign to dislodge Mather. Flora proceeded to have an eviction notice drafted, charging that Mather was in arrears with her rent, a claim Mather vehemently denied in an urgent telegram sent to Weston in Mexico in December 1924.[107] Her protest arrived too late, however. Weston had already boarded a train headed for Los Angeles and his first visit home in a year and a half. His romantic relationship with Tina Modotti had begun to disintegrate, he was homesick for his three youngest children (his oldest son, Chandler, had accompanied him to Mexico), and reports had come to him that his former portrait business was suffering under Mather's restless aegis. Besides, he had his own immediate plans for the studio, as well as designs on the money that might be gained from its sale. Based on events that followed, Weston was either too busy fighting his own battles, or he made a conscious decision not to intervene on Mather's behalf.

FIGURE 20
Margrethe Mather,
Jensigne Jensen,
ca. 1923, platinum/
palladium print.
Collection Sandra
Pitts.

In February 1925, a month after Weston's return, Mather was forced to abandon the tiny, ramshackle bungalow on once-rural Brand Boulevard, now a major thoroughfare rapidly falling victim to increased property values and unrestrained urbanization. While Mather spent her final, melancholy days in the Glendale studio, Weston once again turned his back on his wife and their irreconcilable differences and fled to San Francisco, where he lived and worked until mid-June at 2682 Union Street, in an apartment/studio borrowed from the photographer Dorothea Lange. Those months were unsettling ones for Weston, filled with misgivings about his past and uncertainty about his future, as he struggled for financial security. At the beginning of May, Weston reached an emotional apogee that caused him to pitch the earliest of his journals into a bonfire, destroying all details of his Los Angeles career and his association with Mather. That conflagration marked a dramatic turning point in Weston's life, and in Mather's.

Their professional relationship had ended in rancor, their studio had been dismantled, and their love affair, rekindled so memorably on the sands of Redondo Beach only two years earlier, was now extinguished forever.

When Weston finally wrote about his cathartic act a few weeks later, he defended his decision with bravado. With the passage of a few months and his return to Mexico, his perspective changed, and he bemoaned the destructive impulse that had erased so much of his own history (not to mention Mather's). But he never made any attempt to re-create the story that would have been revealed had those early diaries survived, commenting only:

> *I even regret destroying my day book prior to Mexico: if badly written, it recorded a vital period, all my life with M. M., the first important person in my life; and perhaps even now, though personal contact has gone, the most important. Can I ever write in retrospect? Or will there be someday a renewed contact? It was a mad but beautiful life and love!*[108]

Mather had no choice but to return to her studio on Bunker Hill, where her teenaged friend Billy Justema served as a willing model, just as she had for Weston. Justema had entered her life around the end of 1921, when he came knocking on the door of the Glendale studio one day.[109] An aspiring artist, Justema was only sixteen then,[110] and Mather thirty-five, but the two quickly formed an unusually close bond. As soon as Justema could escape the stifling confines of his family, he moved to downtown Los Angeles, first to rooms overlooking Chinatown and then to an apartment directly across the street from Mather. During this period, Mather photographed Justema's twisting, stretching torso as an abstract form against the bright California sky (plates 69, 70) and made close-ups of his bared midriff revealed through the panels of an intricately patterned Japanese kimono (plate 68). If the date of 1923, generally given to these images, is correct, then they almost certainly influenced several photographs Weston made during the next two years, such as his studies of Tina Modotti wearing a kimono (1924); the truncated torso of his son, Neil (1925); and even his *Hand of Galvan the Potter* (1926). However, the dating of Mather's photographs, which has always been based purely on Justema's memory of their

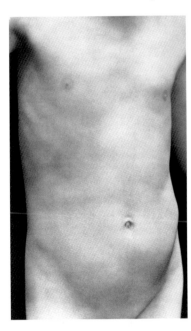

FIGURE 22
Edward Weston, *Neil's Torso*, 1925, platinum/palladium print. Courtesy George Eastman House. © 1981 Center for Creative Photography, Arizona Board of Regents.

FIGURE 23
Edward Weston, Untitled [Tina Modotti in Kimono], 1924, gelatin silver print. San Francisco Museum of Modern Art, Albert M. Bender Collection, Albert M. Bender Bequest Fund Purchase.

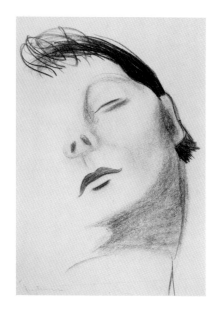

FIGURE 24
Margrethe Mather,
photograph of a
drawing by William
Justema of Margrethe
Mather, ca. 1924,
gelatin silver print.
Collection Center for
Creative Photography,
University of Arizona,
Tucson.

chronology and not on her own notations, cannot be corroborated by any exhibition or publication records. Therefore, the question of their influence remains unresolved.

Mather had many friends in the Japanese community on East First Street, and in 1924 (and, according to Justema, on other occasions as well),[111] she served as a judge, along with the photographers N. P. Moerdyke and Arthur F. Kales, for one of the first exhibitions organized by the Japanese Camera Club of Los Angeles.[112] It was held under the auspices of the *Los Angeles Japanese Daily News*, the local Japanese language newspaper, which was also known as the *Rafu Shimpo*.[113] Reproduced inside the exhibition catalogue was one of her portraits of an adolescent Billy Justema posed in front of one of his sketches of her hands and feet. That same year, Mather's work was the subject of a one-woman exhibition at the venerable Cannell & Chaffin galleries on Seventh Street in downtown Los Angeles. The *Los Angeles Times* review mentioned, in particular, her portraits of the cellist Pablo Casals, actress Eva Gauthier, author Rebecca West, film director Rex Ingram, actor Ramon Novarro, author Konrad Bercovici, and pianists Richard Buhlig (plate 58) and Henry Cowell (plate 72), as well as a still life of a water lily (plate 66) and an industrial study of the Tropico Tile Works.[114]

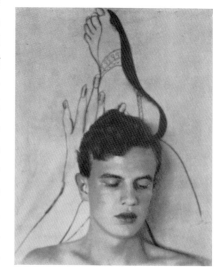

FIGURE 26
Margrethe Mather,
*Billy Justema with
Drawing*, early 1920s,
medium unknown,
reproduced from *Art-
Gram*, catalogue from
Los Angeles Japanese
Pictorialists exhibi-
tion, 1924. Collection
Dennis Reed.

THE EXPOSÉ OF FORM

As the months passed, Mather began to lose interest in photography in spite of Justema's encouragement. He brought her objects to photograph, attempting to inspire her, but Mather's concentration was flagging. She also suffered from health problems, which she attempted to assuage by using opium and alcohol to dull the symptoms.[115] Still, she continued to make memorable photographs and, for the first time, looked to the world outside her studio for subject matter. Her images of an abandoned automobile (plate 71), the swollen belly of a Japanese wrestler (plate 73), a "fat lady" circus poster (plate 74), and scenes from the local Chinese opera (plates 75,

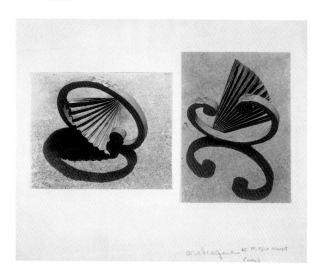

FIGURE 25
Margrethe Mather,
Arabesque, ca. 1925,
gelatin silver print.
Collection Center for
Creative Photography,
University of Arizona,
Tucson.

77) all date from around 1927, and may have been done for an exhibition she organized for Aline Barnsdall and the California Arts Club that same year.[116]

By 1928 she and Justema were desperate for money. They decided to apply for a grant from the recently formed Guggenheim Foundation and jointly submitted a proposal for a project they called "The Exposé of Form" to the 1929 competition.[117] In it they described some of the photographs they had been working on since 1925. Included were images of fans, hands, eggs, melons, waves, bathroom fixtures, seashells, and birds' wings,[118] all subjects that Weston would also explore, beginning with his *Excusado* pictures in October 1926, and continuing with his nautilus shell photographs in the spring of 1927 and his *Pelican's Wing* in 1931. Weston later acknowledged, albeit begrudgingly, the possibility that he had been inspired to photograph the porcelain toilet bowl in his Mexico City apartment after seeing Mather's work during his first visit home to Los Angeles in 1925:

> *May 7 [1927] . . . M. tells me she was doing toilets when I was here from Mexico last time. I don't remember, but offer thanks if the idea came through her. I was sure to have done my toilet, suggestion from outside or no!*[119]

When Mather and Justema's Guggenheim proposal failed to receive funding, she put aside her camera and began to work for a friend in a small gift shop in downtown Los Angeles. About that same time she renewed her acquaintance with a garrulous, hard-drinking man named George Lipton, who had been one of her anarchist friends during the teens.[120] He was newly widowed and Mather began to console him, moving into the apartment over his upholstery/antique shop on Hollywood Boulevard but retaining her Bunker Hill studio, where she could make an occasional portrait when the need arose. In this way she continued with her photography for a few more months, sometimes going "on location" to create atmospheric, moody stylings or chic, clever excerpts of interiors for decorator friends (plates 79, 80, 81, 82), at other times making "glamour" portraits of some of her old acquaintances from the movie business (plate 78). But her enthusiasm had definitely waned.

Meanwhile, at the end of 1926, Weston had returned from Mexico to reclaim his dilapidated former studio for a few months before finally settling in Carmel-by-the-Sea, the artists' community south of San Francisco, where his artistic growth would continue, unabated, until the late 1940s. Even though Weston and Mather had rather gingerly reestablished communications after his return to California, when he wrote in March 1929, asking her to be one of the American contributors to the landmark German photography exhibition *Film und Foto* opening in Stuttgart that summer, she never bothered to respond.[121]

In late 1930 Justema, who had recently moved to San Francisco, secured an exhibition for Mather at the M. H. de Young Memorial Museum, then in the midst of plans for a gala reopening to celebrate the reorganization of its collections by a new director.[122] For

a few months Mather became excited about photography again. Just before the Christmas holidays she moved to San Francisco, rented a studio at 555 Sutter Street, around the corner from Union Square, and, with Justema's assistance, set about making the images that would be her final contribution to photography. When the exhibition opened the following July, reviewers referred to her as "Margrethe Mather, San Francisco modernist."[123] The unifying theme of her exhibition was related both to her earlier Guggenheim proposal and to the museum's newly announced mission as a decorative and graphic arts museum. She arranged objects in repetitive patterns in order to photograph them as prototypes for textiles and interior design components. Although Edward Steichen had attempted a similar project for the Stehli Silk Corporation four years earlier,[124] Mather's approach was markedly different and more successful than Steichen's. Her photographs, sharply focused and printed as enlargements on glossy paper, were more dramatically modern in feeling and more cleverly surreal in concept, incorporating objects such as fans, combs, broken china,

chain links, cigarettes, alarm clocks, shells, glass eyes, and ticker tape (plates 83, 84, 85, 86, 87, 88) into designs suitable for mass production on bolts of silk and polished cotton, or as templates for ceramic tile and pressed glass. It may have been the interest generated by Mather's photographs, the first shown at the museum under newly appointed director Lloyd LaPage Rollins, that prompted Rollins to invite Weston to exhibit there six months later[125] and then, in December 1932, to mount a display of new work by a loosely organized cadre of California photographers (including Weston) who had decided to call themselves Group f.64.[126]

After her San Francisco exhibition ended, Mather returned to Los Angeles and George Lipton, and spent the next twenty years living and working with him as they moved their shop from one location to another in Glendale and Los Angeles. Although Mather occasionally accepted magazine assignments (plate 89) and made portraits for friends, her photographic career was essentially over by the mid-thirties. In early 1939 she suffered a badly shattered ankle that left her on crutches for several months,[127] and, by the end of the 1940s, her general health was seriously declining. When a medical diagnosis finally came, it explained the many, seemingly unrelated, physical ailments that had long plagued her, as well as her periodic bouts with depression—her affliction was multiple sclerosis.[128]

Margrethe Mather presents a symbolic abstraction of the debut in these modern photographs of exquisitely fashioned slippers and long black gloves.

DEBUT

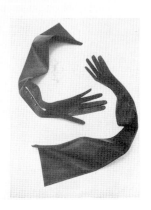

Dancing feet . . laughing gaiety . . the long black gloves of convention . . . ambition . . . romantic hopes . . . the modern rite of the debut is performed! Meaningless in the part it originally played—significant in its social symbolism, the debut will continue its public acknowledgment of the usages of tradition.

Mather spent the last few months of her life confined to a wheelchair, cared for by Lipton in her now decrepit studio on Bunker Hill, where they had returned to live just after World War II.[129] When the property was finally condemned and the owner forced to sell in the late summer of 1952,[130] it became necessary for Lipton to find a new place where he could continue to tend to Mather and carry on his antiques business. In her weakened state, the stress of the move was too much for Mather. Within a few weeks of relocating, on Christmas Day, 1952, she died at the age of sixty-six.[131] In the official death records her name appeared as "Margaret Lipton," an identity she never actually acquired but one that reflected her common-law status as the longstanding, live-in companion of George Lipton. Her occupation was described as "housewife," a bureaucrat's superficial summation of her role in life, and a perfunctory epitaph that belied her former status as a well-known professional. Weston would outlive Mather by five years although he, too, was already seriously ill with Parkinson's disease.[132] By the time the first volume of his much-edited *Daybooks* was finally published in 1961, all that remained of Mather's story were Weston's scattered mentions of her and Newhall's lyrical introductory paragraph.

FIGURE 30
Margrethe Mather, Tearsheet from *The San Franciscan*, February 1931. Collection Library, Getty Research Institute, Los Angeles (920060).

Margrethe Mather's ambivalence toward her own place in photographic history undoubtedly stemmed from trepidation about being recalled merely as Weston's model and lover. Her fear proved well-founded. Now, fifty years after her death, photographic history finally can be revised to reflect the fact that, first and foremost, Margrethe Mather was an extraordinary photographer on her own merit. For a decade, between 1915 and 1925, she was one of the best-known and most-honored female photographers in America, ranking behind only Gertrude Kasebier, Jane Reece, and Anne Brigman, who were all a generation older and longer established. On numerous occasions, in salon competitions, she received awards and recognition ahead of her male peers. Although she began her foray into photography as an uncommitted amateur, she rapidly evolved into a highly respected professional. And only after her own contributions have been fully assessed should she also be remembered as Edward Weston's first mentor, his guide to the artistic and literary bohemia of Los Angeles, and the person who repeatedly challenged him to learn all he could from others and to constantly distill his vision.

Margrethe Mather was a rebel in every way. She could not abide rules, bureaucracy, or bourgeois attitudes. Despite indisputable talent and intelligence, she lacked many of the personality attributes that Weston possessed. Notably, she was not disciplined, nor was she particularly ambitious. She was not a self-promoter and she was not always reliable. She was guarded, secretive, and reserved. At the same time, she was generous and kind and romantic. She did not always choose her friends and lovers wisely, but her life was large, colorful, exciting, and sometimes tragically sordid as a result. As a female artist of the early twentieth century, linked for so much of her career to a male artist of the first magnitude, she has remained almost invisible, virtually hidden in the darkest recesses of Weston's shadow. And he seems to have been quite content to let her languish there after years of encouraging and promoting her brought him only frustration with her unpredictable ways.

Nevertheless, with her unerring eye for spare, elegant design, her unflinching capacity for editing an image to its very essence, and her obsession with technical perfection, Margrethe Mather was an artist of real substance and significance. She was a pacesetter and an innovator, and that, in the end, is how she deserves to be remembered.

Plates

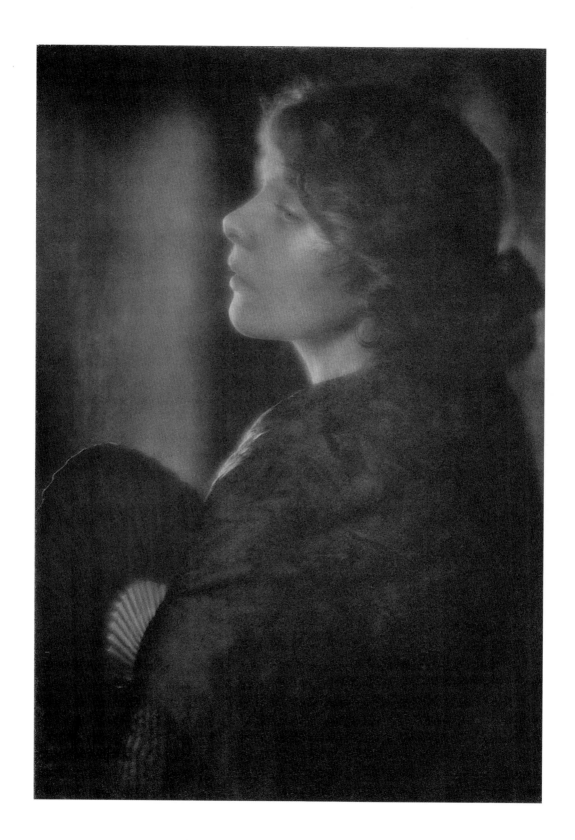

1. Edward Weston, *Carlota*, 1914, platinum/palladium print.
Collection John J. Medveckis.

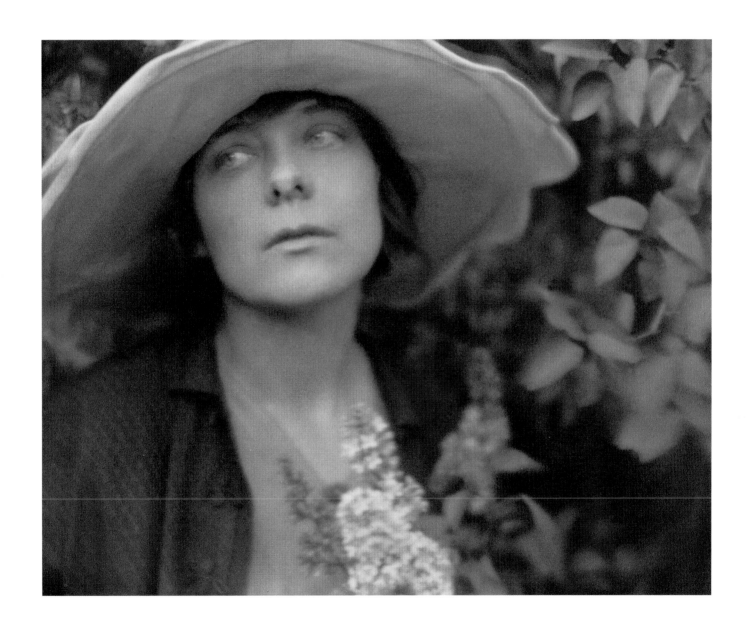

2. Edward Weston, *Margrethe in Garden*, ca. 1915, platinum/palladium print. Collection Center for Creative Photography, University of Arizona, Tucson. © 1981 Center for Creative Photography, Arizona Board of Regents.

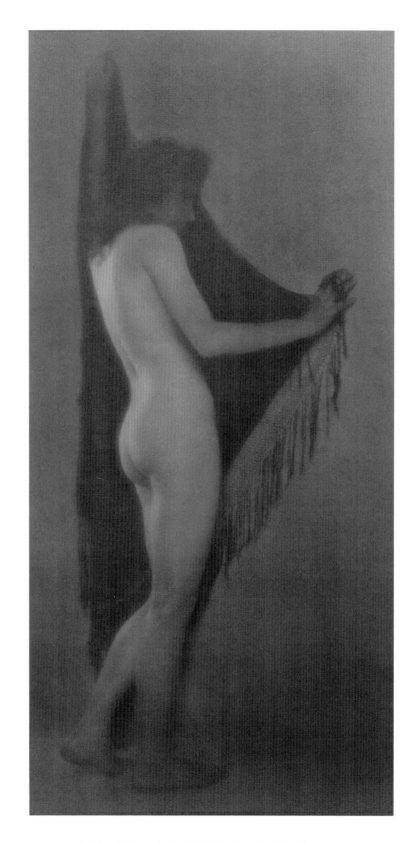

3. Edward Weston, *Nude with Black Shawl*, 1915, gelatin silver print.
Courtesy Peter Fetterman Gallery.

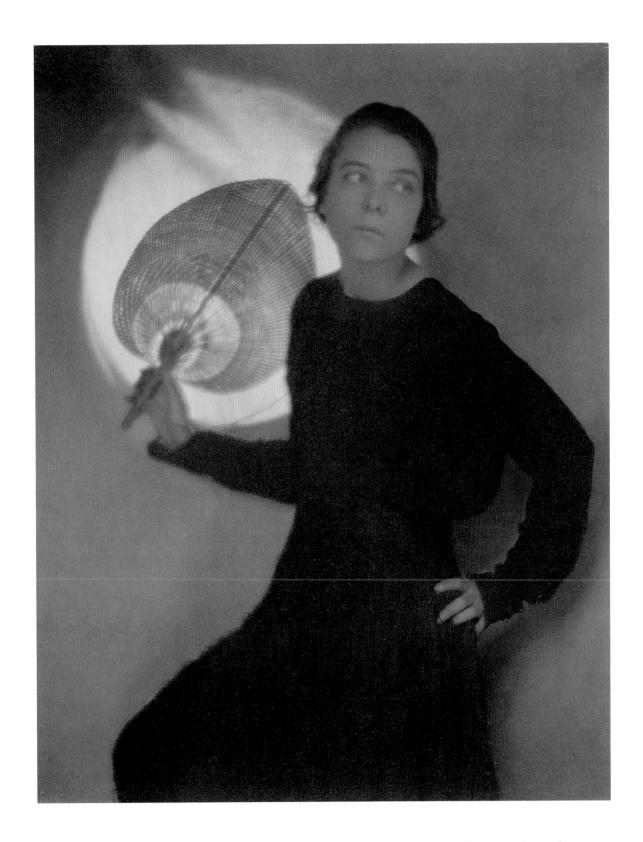

4. Edward Weston, *The Fan—Margrethe Mather*, 1917, platinum/palladium print. Collection Center for Creative Photography, University of Arizona, Tucson. © 1981 Center for Creative Photography, Arizona Board of Regents.

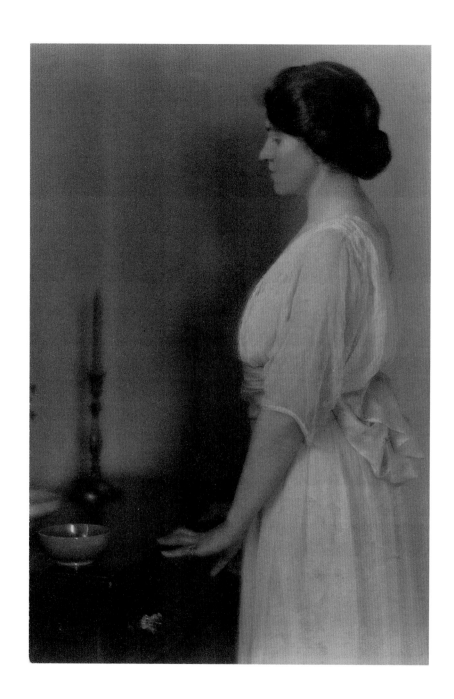

5. Margrethe Mather, *Mollie Price Cook*, 1916, platinum/palladium print.
Collection Mrs. Sirius C. Cook.

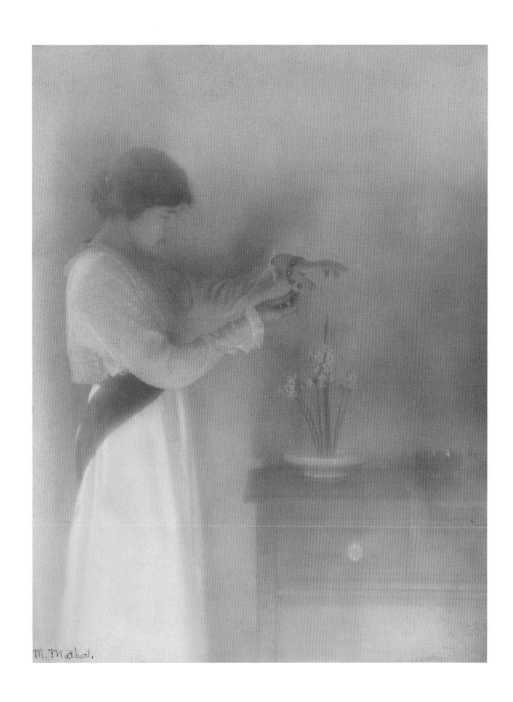

6. Margrethe Mather, *Maud Emily Taylor*, 1916, platinum/palladium print.
Private collection.

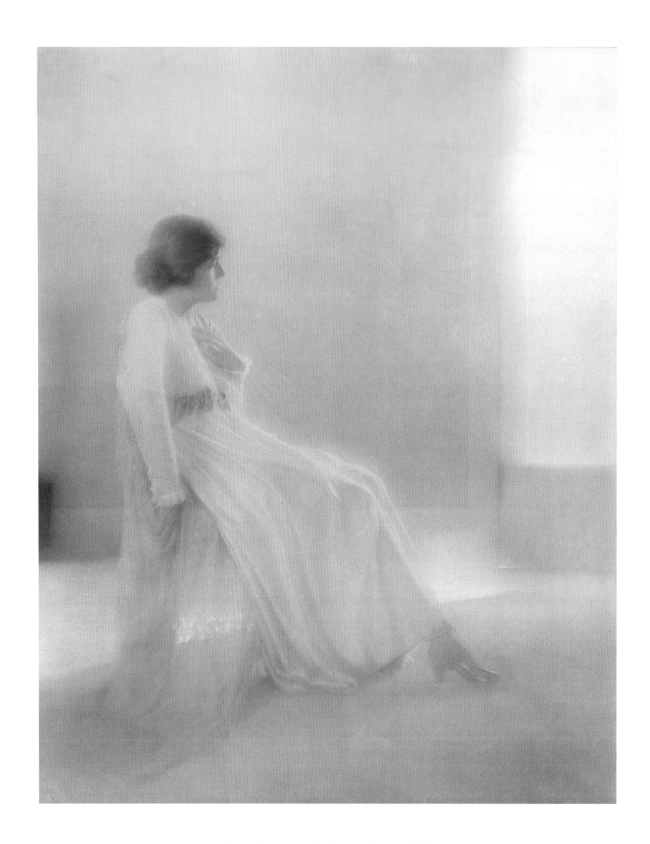

7. Margrethe Mather, *Miss Maud Emily*, 1916, platinum/palladium print.
Collection San Francisco Museum of Modern Art, gift of Nikki Arai and Simon Lowinsky in honor of John Humphrey.

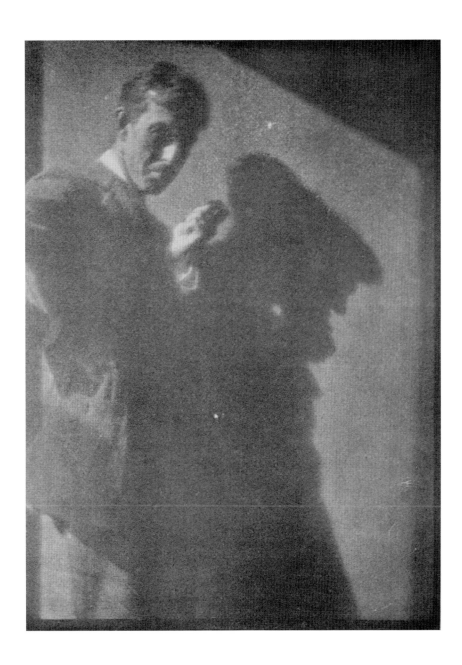

8. Edward Weston, *Eugene Hutchinson*, 1916, medium unknown, reproduced from *American Photography*, July 1917. Collection Center for Creative Photography, University of Arizona, Tucson. © 1981 Center for Creative Photography, Arizona Board of Regents.

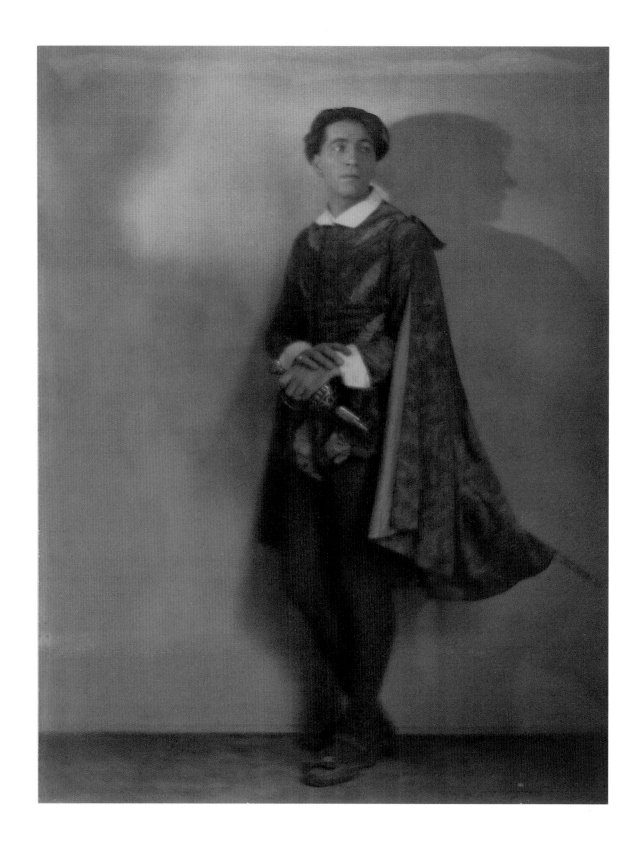

9. Margrethe Mather, *Frayne Williams as Hamlet*, ca. 1918, platinum/palladium print.
Collection Jenifer Williams Angel.

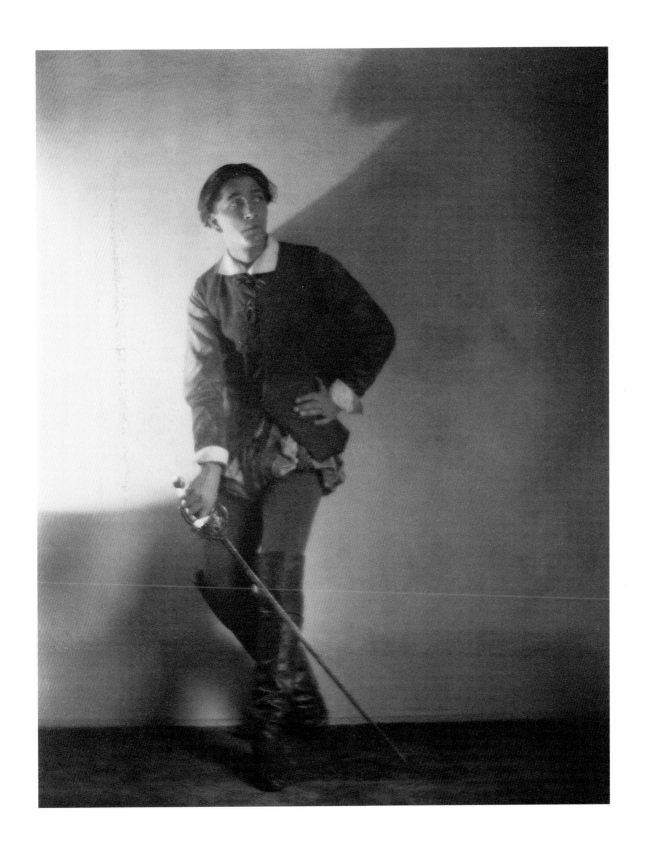

10. Margrethe Mather, *Frayne Williams as Hamlet*, ca. 1918, platinum/palladium print.
Collection Michael and Jane Wilson.

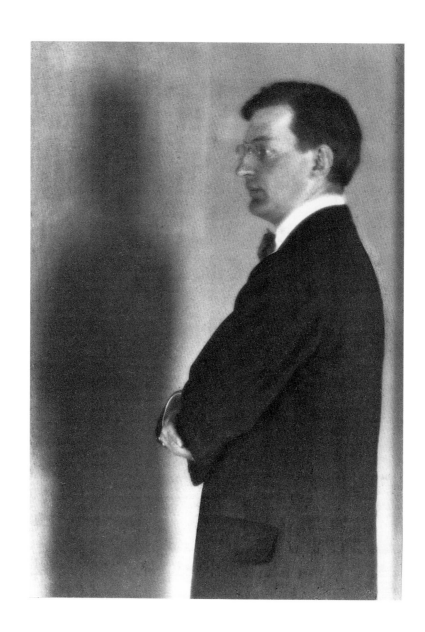

11. Margrethe Mather, *Alfred Kreymborg*, 1917, platinum/palladium print.
Collection The J. Paul Getty Museum, Los Angeles.

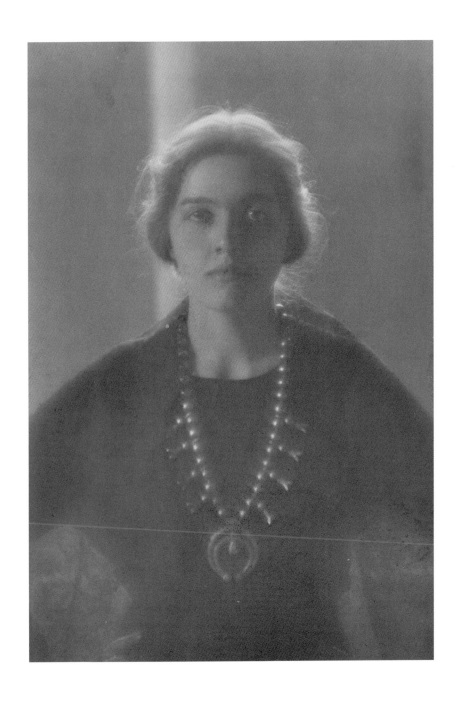

12. Margrethe Mather, *Maud Emily Taylor Wearing Squash Blossom Necklace*, ca. 1918, platinum/palladium print.
Private collection.

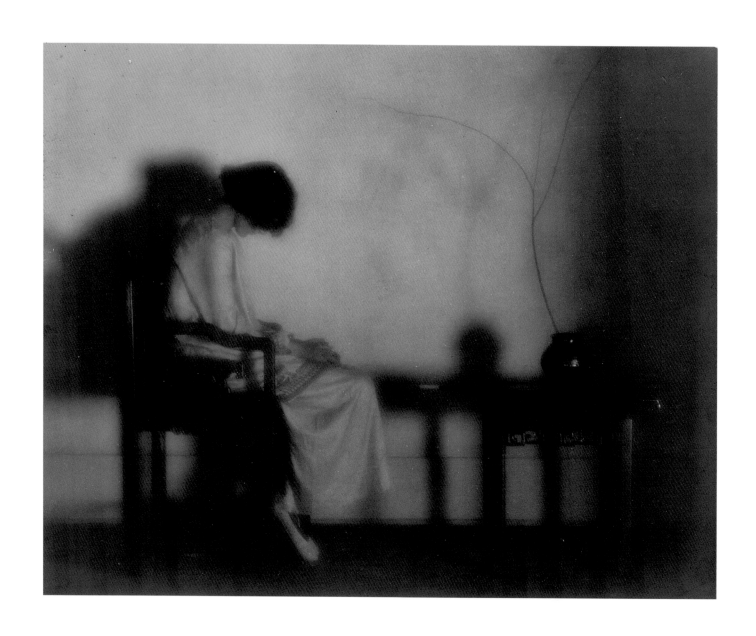

13. Margrethe Mather, *Maud Emily Taylor Seated in Chinese Chair*, ca. 1918, platinum/palladium print.
Private collection.

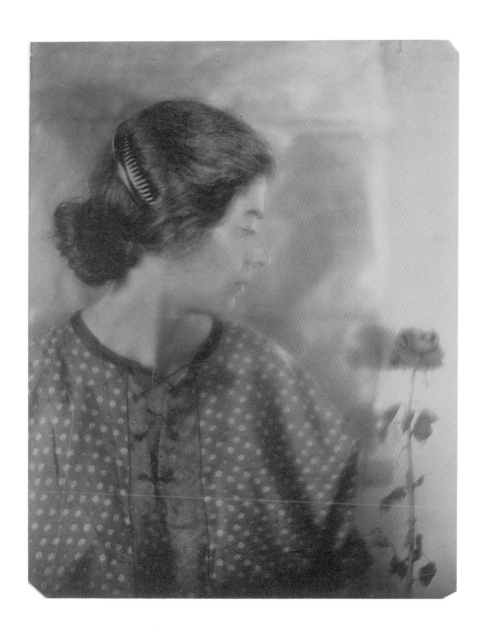

14. Margrethe Mather, *Betty Katz with Rose*, ca. 1918, platinum/palladium print.
Collection The J. Paul Getty Museum, Los Angeles.

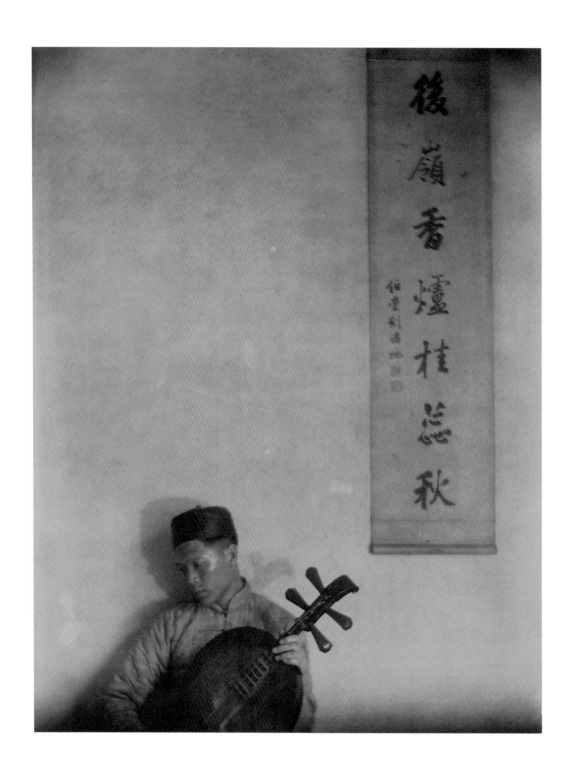

15. Margrethe Mather, *Player on the Yit-Kim*, 1918, platinum/palladium print.
Peil/Leonard Collection, courtesy Fraenkel Gallery.

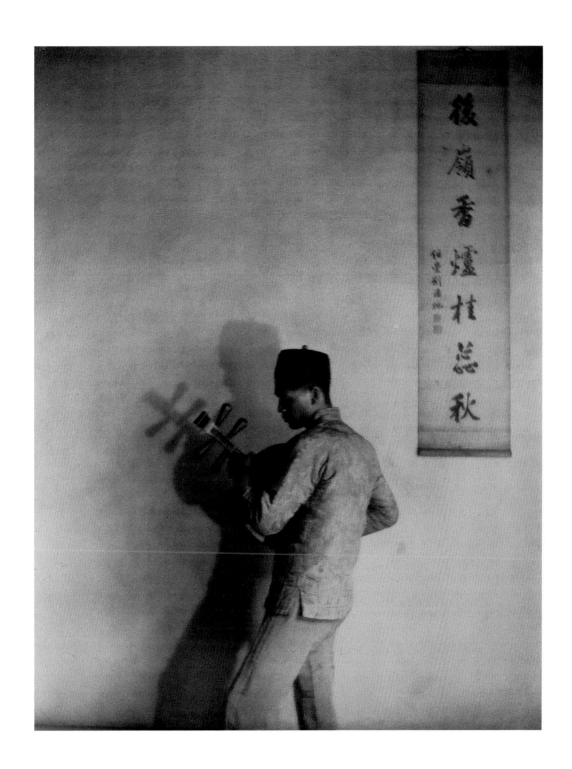

16. Margrethe Mather, *Moon Kwan on the Yit-Kim,* 1918, platinum/palladium print.
Collection Ella Strong Denison Library, Scripps College.

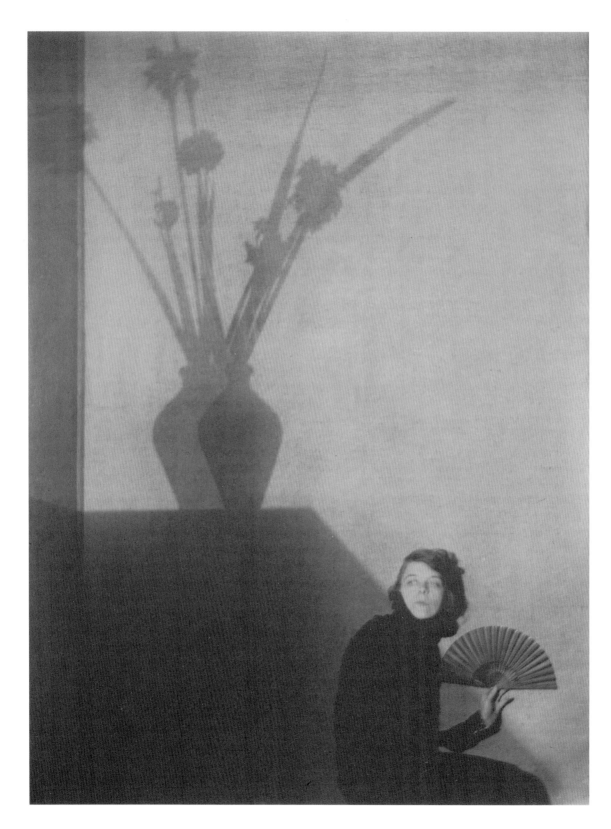

17. Edward Weston, *Epilogue*, ca. 1919, platinum/palladium print.
Collection National Museum of American History, Smithsonian Institution.

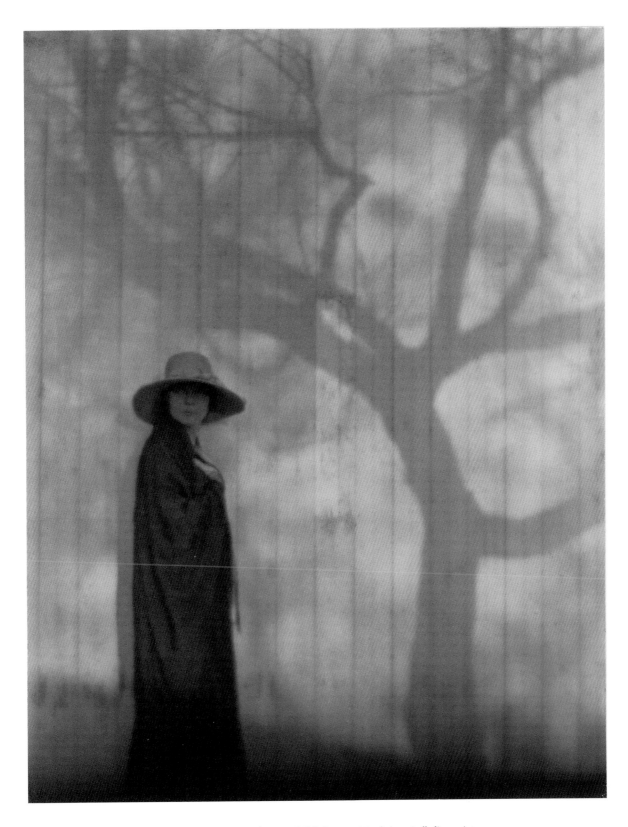

18. Edward Weston, *Prologue to a Sad Spring*, ca. 1919, platinum/palladium print.
Collection Marjorie and Leonard Vernon.

19. Margrethe Mather, *"Wild Joe" O'Carroll*, ca. 1919, platinum/palladium print.
Collection Yvette Eastman.

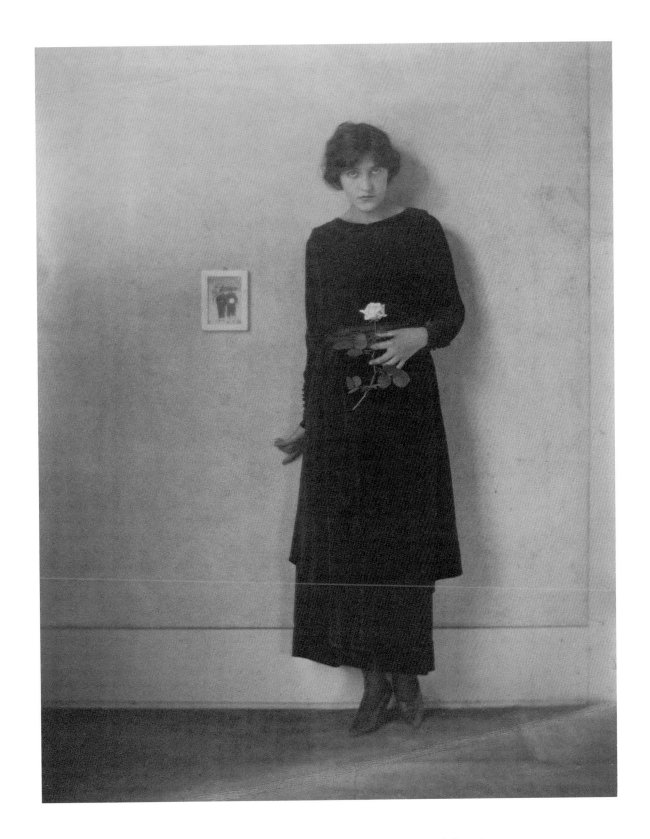

20. Margrethe Mather, *Florence Deshon with Rose*, ca. 1919, platinum/palladium print.
Collection Yvette Eastman.

21. Margrethe Mather, *Florence Deshon*, ca. 1919, platinum/palladium print.
Collection Yvette Eastman.

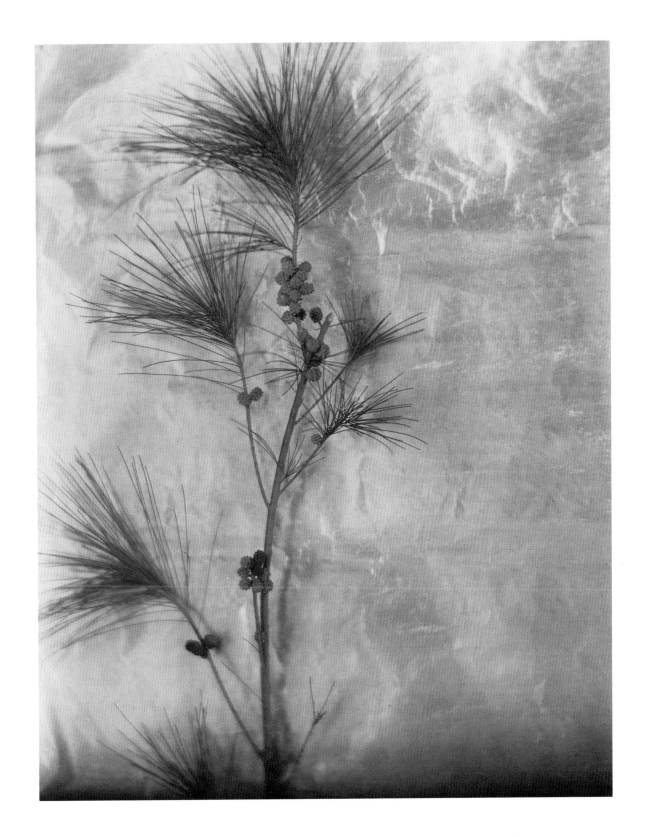

22. Margrethe Mather, *Pointed Pines*, 1920, platinum/palladium print. The Metropolitan Museum of Art; purchase, Mr. and Mrs. Robert J. Massar; gift, 1971. © 1999 The Metropolitan Museum of Art.

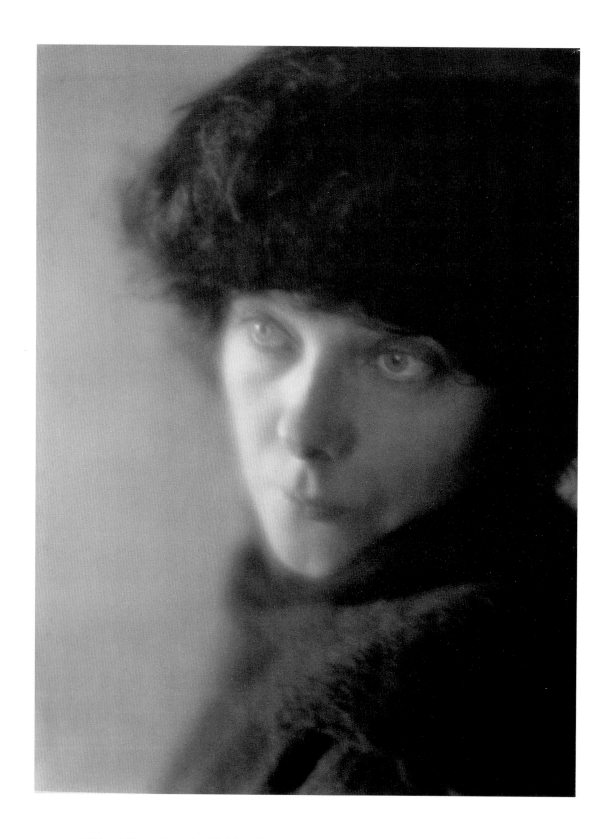

23. Edward Weston, *Margrethe in Glendale Studio*, ca. 1920, platinum/palladium print. Collection Center for Creative Photography, University of Arizona, Tucson. © 1981 Center for Creative Photography, Arizona Board of Regents.

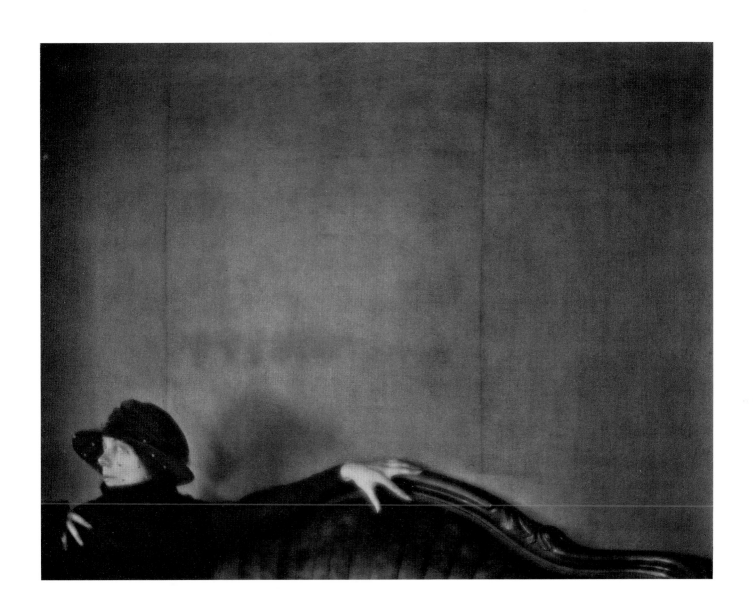

24. Edward Weston, *Glendale Studio*, ca. 1920, platinum/palladium print. Collection Center for Creative Photography,
University of Arizona, Tucson. © 1981 Center for Creative Photography, Arizona Board of Regents.

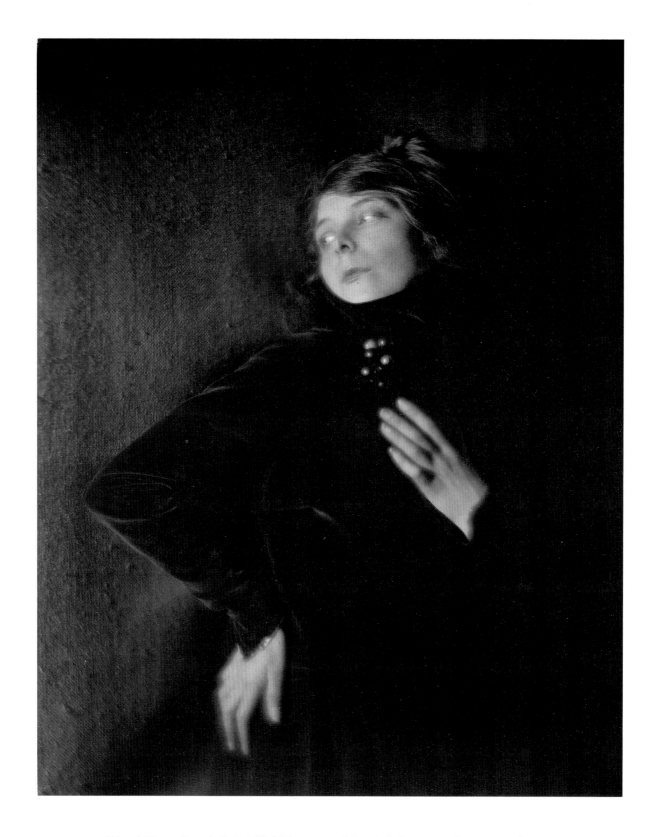

25. Edward Weston, *Margrethe Mather in Black Velvet*, ca. 1920, platinum/palladium print. Collection Center for Creative Photography, University of Arizona, Tucson. © 1981 Center for Creative Photography, Arizona Board of Regents.

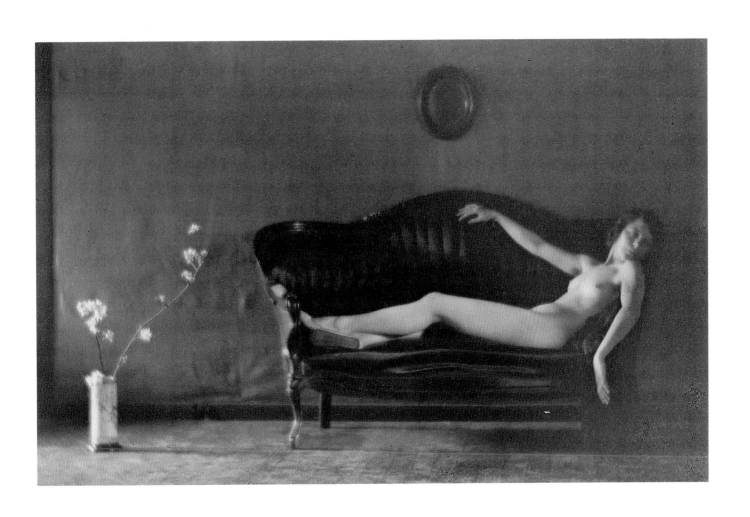

26. Edward Weston, *Margrethe Mather on Horsehair* Sofa, ca. 1920, platinum/palladium print.
Collection Michael and Jane Wilson.

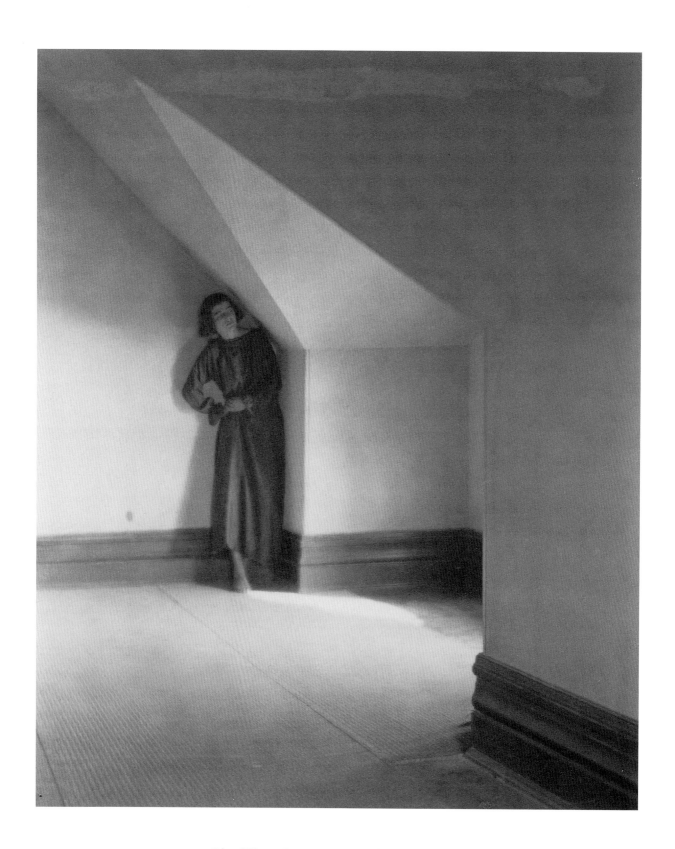

27. Edward Weston, *Betty in Her Attic*, 1920, platinum/palladium print.
Collection The J. Paul Getty Museum, Los Angeles.

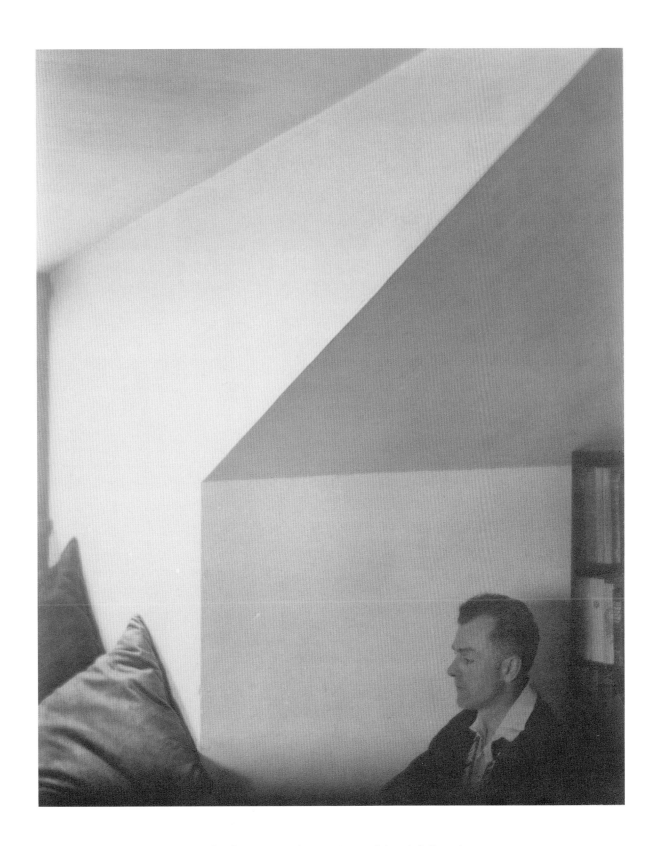

28. Edward Weston, *Ramiel in His Attic*, 1920, platinum/palladium print.
Collection National Museum of American History, Smithsonian Institution.

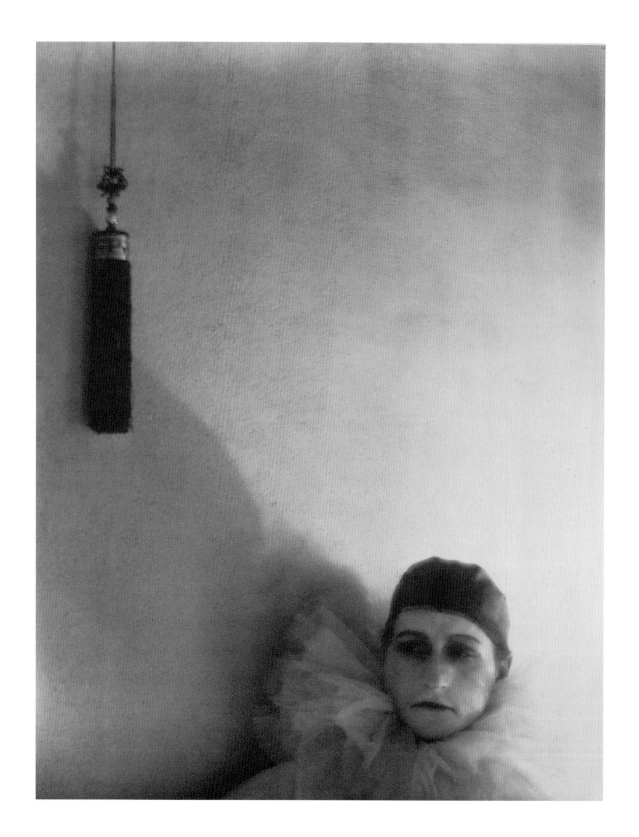

29. Margrethe Mather, *Pierrot*, 1920, platinum/palladium print.
Collection San Francisco Museum of Modern Art, gift of Elise S. Haas, in honor of Clifford R. Peterson.

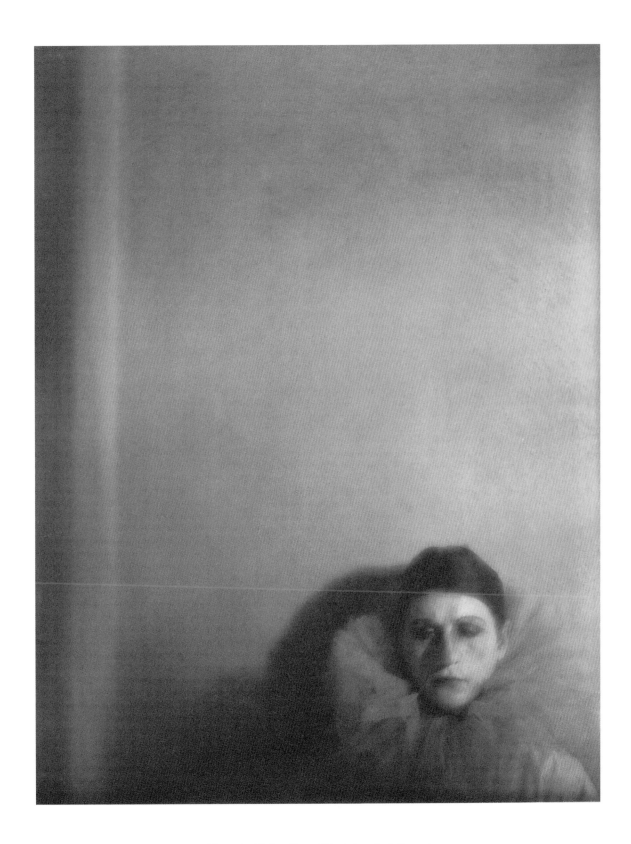

30. Margrethe Mather, *Pierrot*, 1920, platinum/palladium print.
Collection National Museum of American History, Smithsonian Institution.

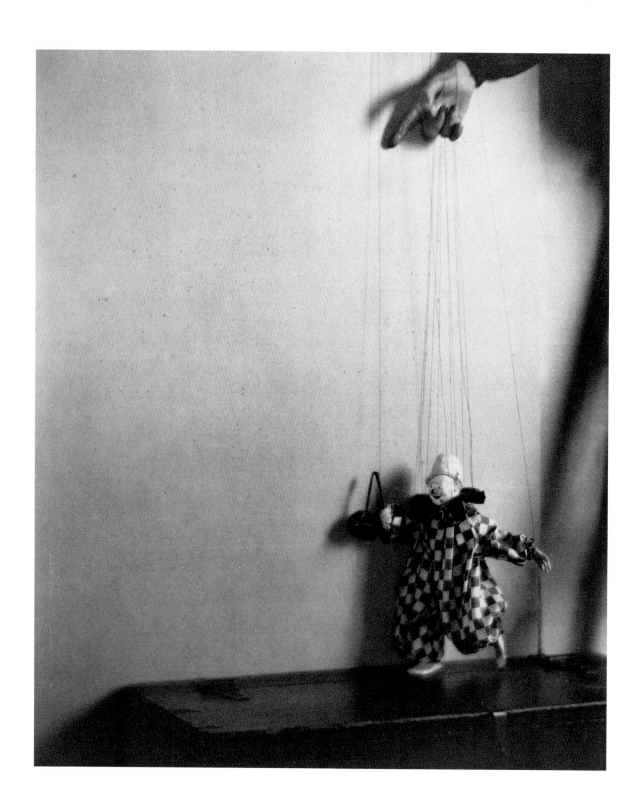

31. Margrethe Mather, *Marionette*, ca. 1920, platinum/palladium print.
Collection Hallmark Photographic Collection, Hallmark Cards, Inc.

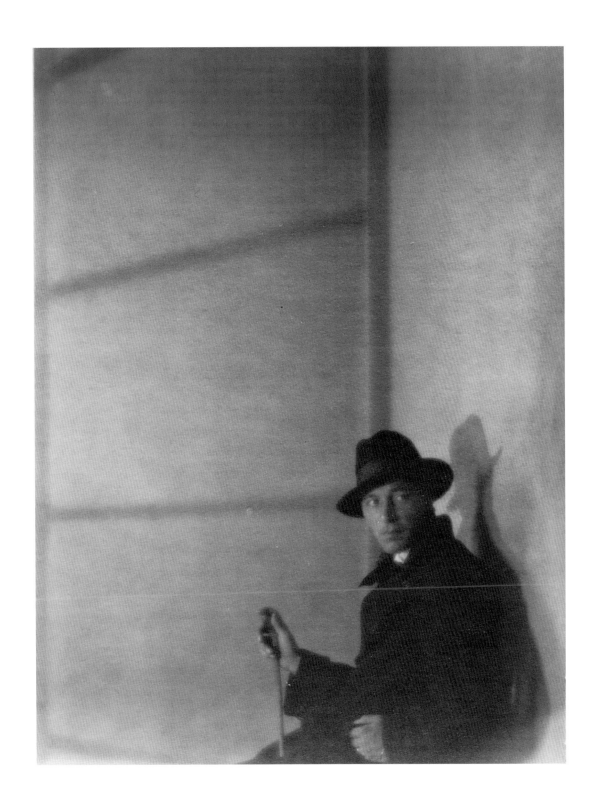

32. Margrethe Mather, *Frayne Williams as Anatol*, 1920, platinum/palladium print.
Collection Richard Shenk; courtesy Joel Soroka Gallery.

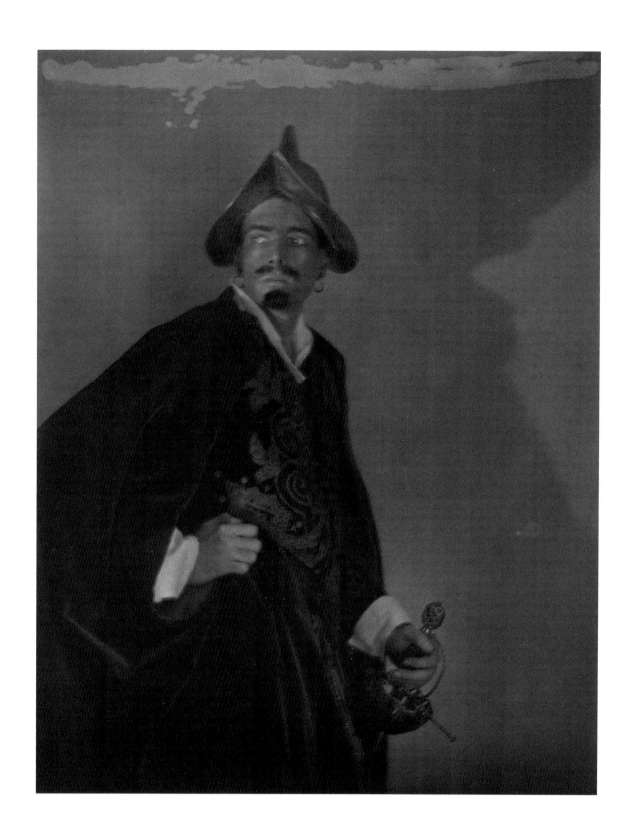

33. Margrethe Mather, *Reginald Poel* [Pole] *as Othello,* 1920, platinum/palladium print.
Collection Jenifer Williams Angel.

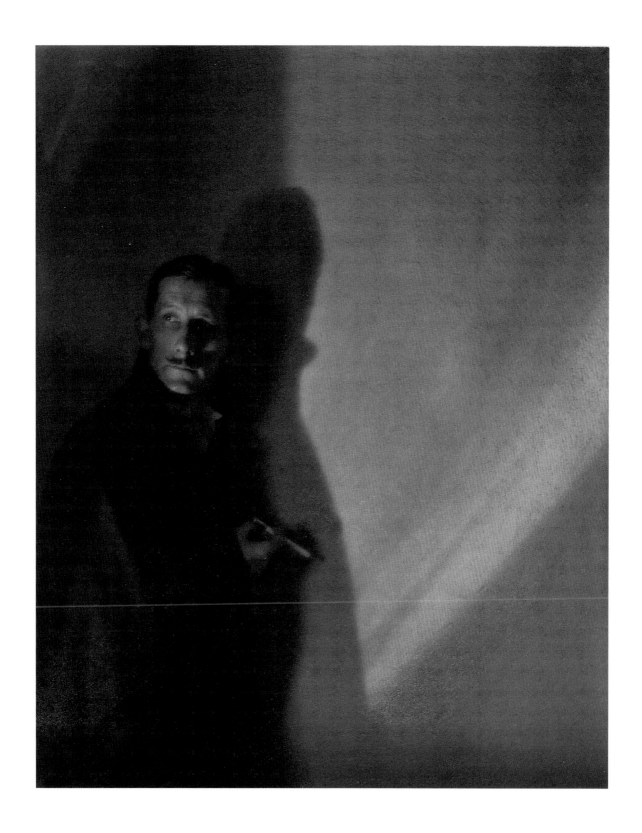

34. Margrethe Mather, *Charles Gerrard with Waxed Moustache*, 1920, platinum/palladium print.
Collection Bowdoin College Museum of Art, Brunswick, Maine; purchase, Lloyd O. and Marjorie Strong Coulter Fund.

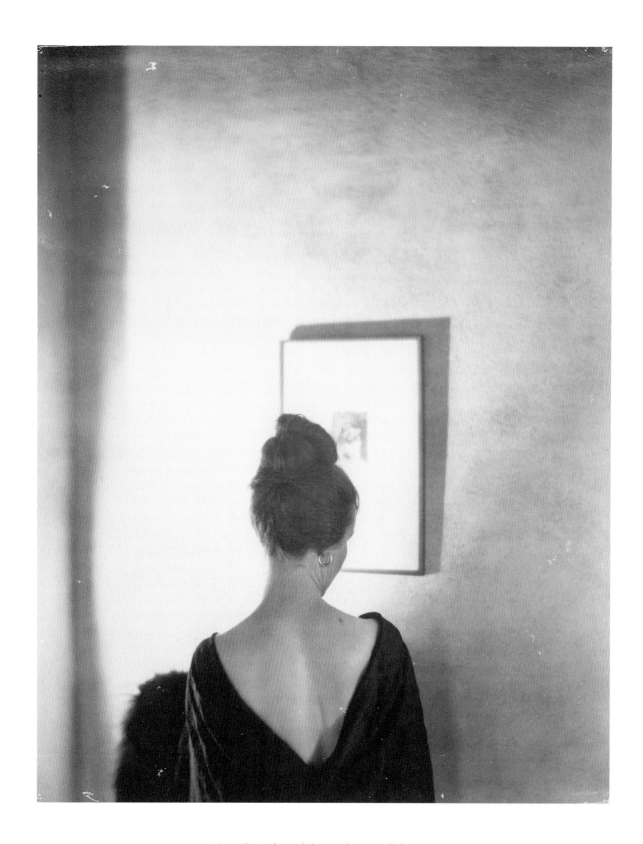

35. Margrethe Mather, *Judith*, 1920, platinum/palladium print.
Collection Center for Creative Photography, University of Arizona, Tucson.

36. Margrethe Mather and Edward Weston, *Carl Sandburg*, 1921, platinum/palladium print.
Collection JGS, Inc.

37. Margrethe Mather and Edward Weston, *Max Eastman, Poet,* 1921, platinum/palladium print.
Private collection; courtesy Sotheby's Inc.

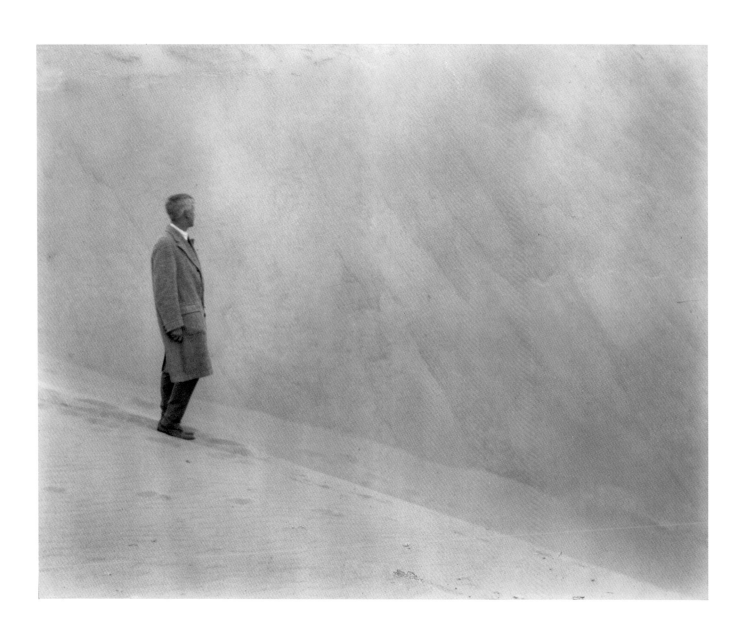

38. Margrethe Mather and Edward Weston, *Max Eastman on Beach*, 1921, platinum/palladium print.
Collection The Museum of Modern Art.

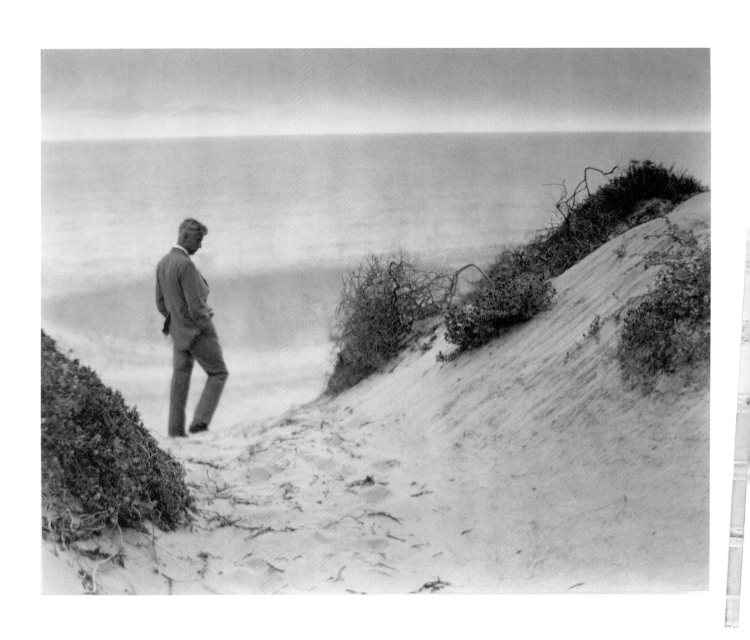

39. Margrethe Mather and Edward Weston, *Max Eastman at Water's Edge*, 1921, platinum/palladium print.
Private collection; courtesy Sotheby's, Inc.

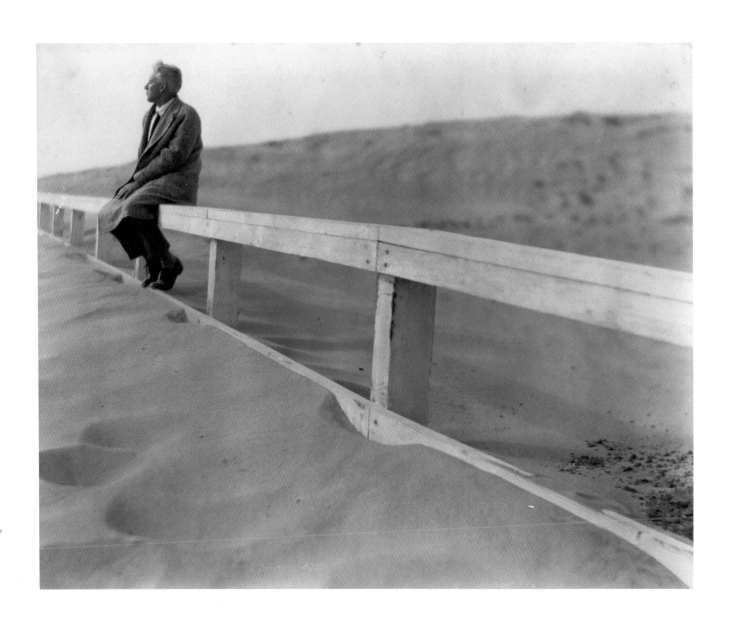

40. Margrethe Mather and Edward Weston, *Max Eastman Seated on Railing*, 1921, platinum/palladium print.
Collection The Museum of Modern Art.

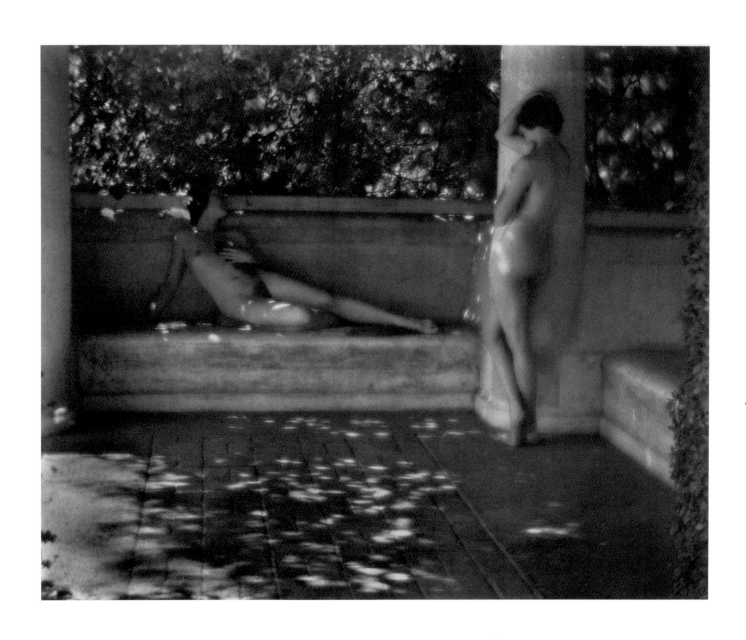

41. Margrethe Mather and Edward Weston, *The Marion Morgan Dancers*, 1921, platinum/palladium print.
Collection Sandor Family.

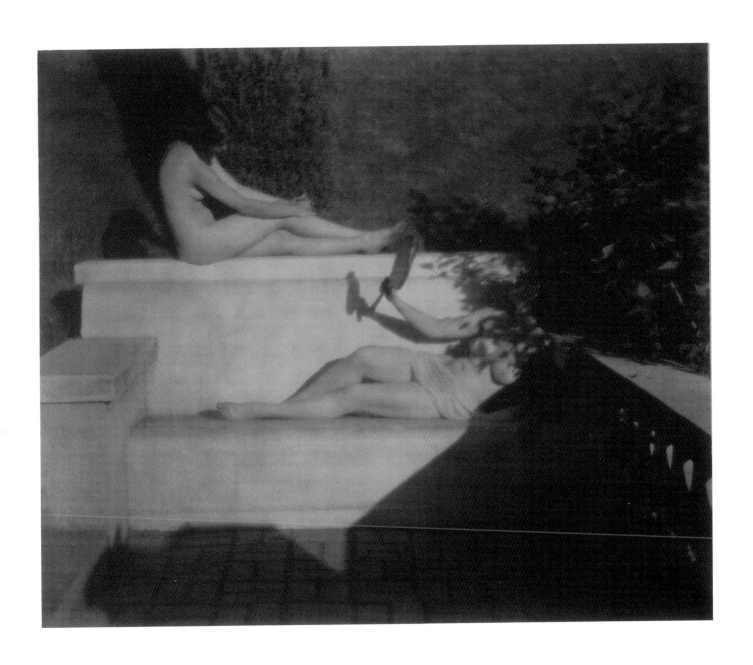

42. Margrethe Mather and Edward Weston, *The Marion Morgan Dancers*, 1921, platinum/palladium print.
Collection Michael and Jane Wilson.

43. Margrethe Mather and Edward Weston, *Gjura Stojana*, 1921, platinum/palladium print.
Collection The J. Paul Getty Museum, Los Angeles.

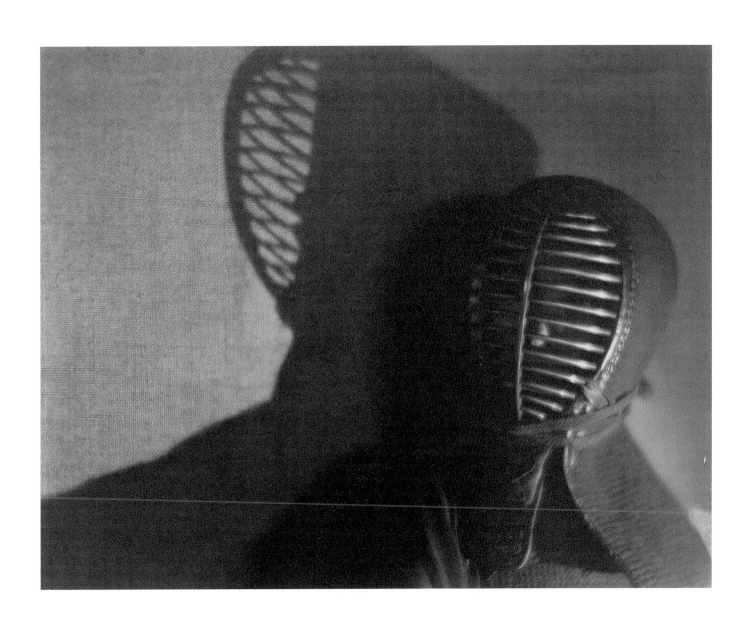

44. Edward Weston, *Japanese Fencing Mask*, 1921, platinum/palladium print.
Collection Michael and Jane Wilson.

45. Edward Weston, *Head of an Italian Girl* [Tina Modotti], 1921, platinum/palladium print.
Collection Michael and Jane Wilson.

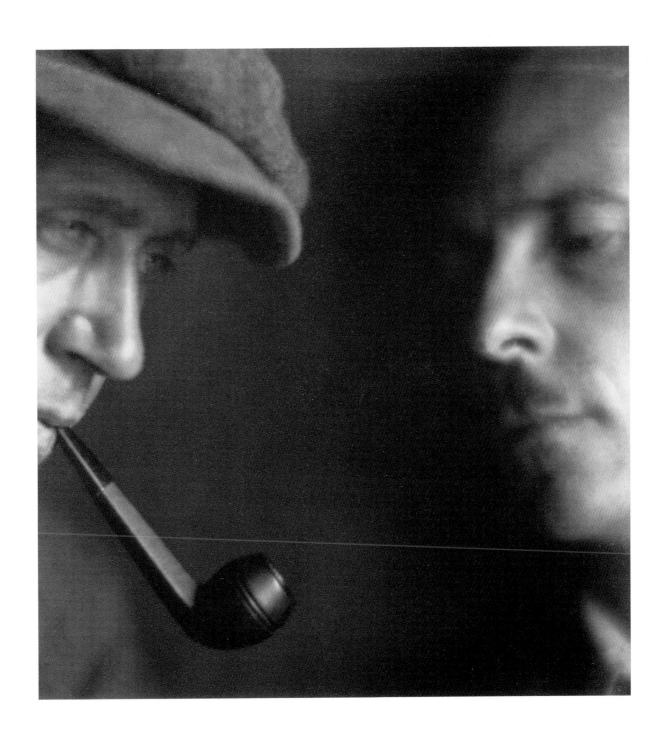

46. Margrethe Mather, *Johan Hagemeyer and Edward Weston*, 1921, platinum/palladium print.
Collection Center for Creative Photography, University of Arizona, Tucson.

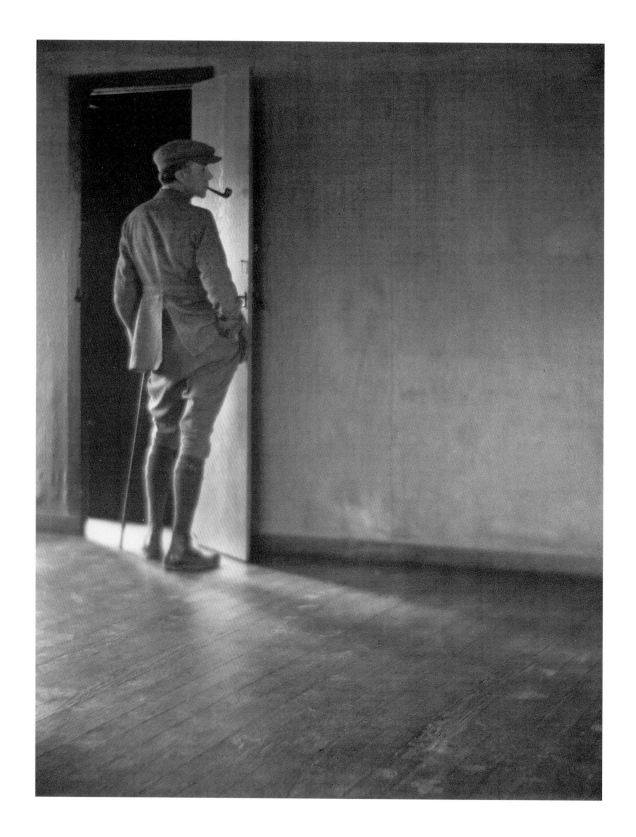

47. Margrethe Mather, *Johan Hagemeyer*, 1921, platinum/palladium print.
Collection Center for Creative Photography, University of Arizona, Tucson.

48. Margrethe Mather, *Edward Weston in Cape and Glasses*, ca. 1921, platinum/palladium print.
Collection The Museum of Modern Art.

49. Margrethe Mather, *Edward Weston*, 1921, platinum/palladium print.
Collection The J. Paul Getty Museum, Los Angeles.

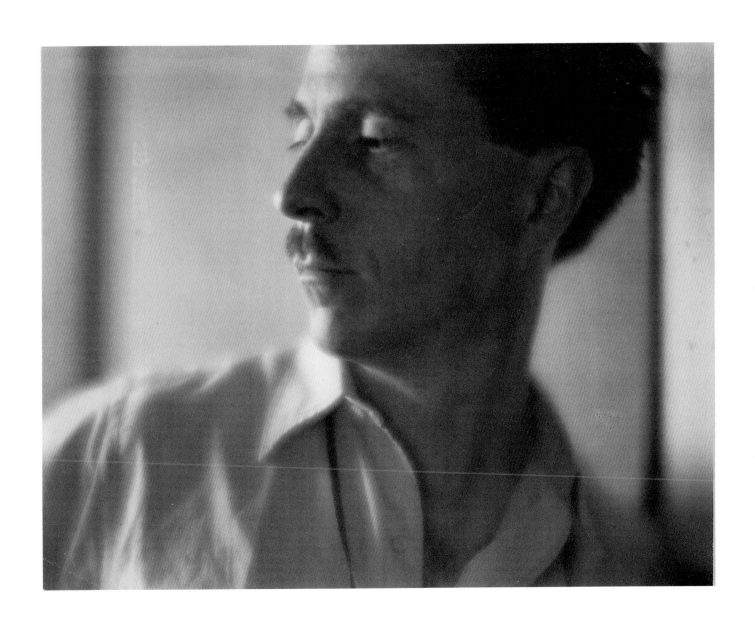

50. Margrethe Mather, *Edward Weston*, 1921, platinum/palladium print.
Courtesy George Eastman House, gift of Brett Weston.

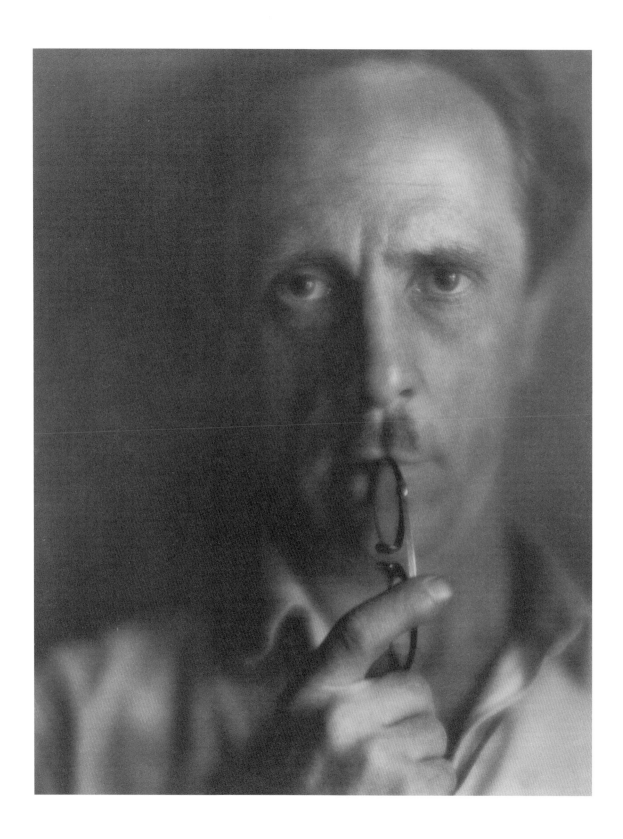

51. Margrethe Mather, *Edward Weston*, 1921, platinum/palladium print.
Collection Isaac Lagnado.

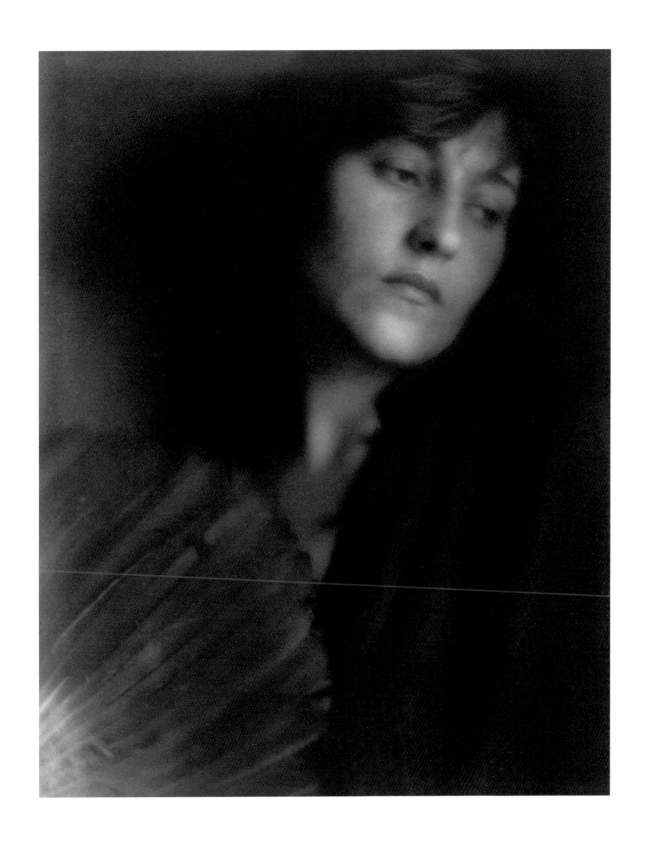

52. Margrethe Mather, *Florence Deshon with Fan*, 1921, platinum/palladium print.
Collection Oakland Museum of California, gift of Dr. and Mrs. Dudley P. Bell.

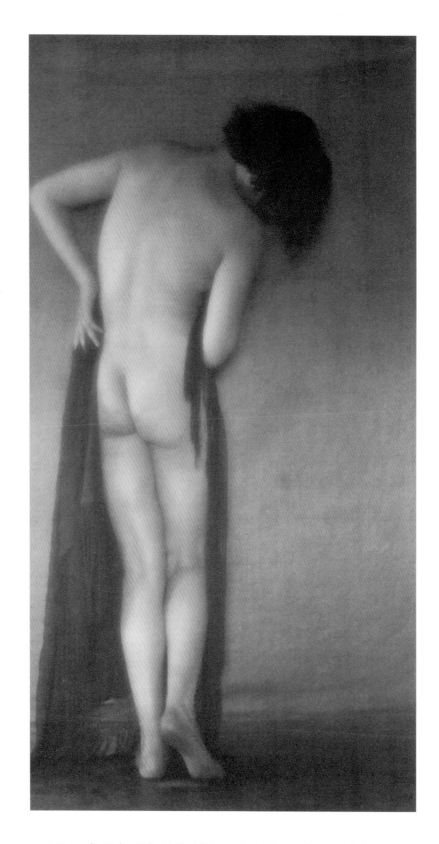

53. Margrethe Mather, *Nude with Shawl* [Florence Deshon], 1921, platinum/palladium print.
Courtesy George Eastman House, museum purchase, ex-collection Mrs. Max Eastman.

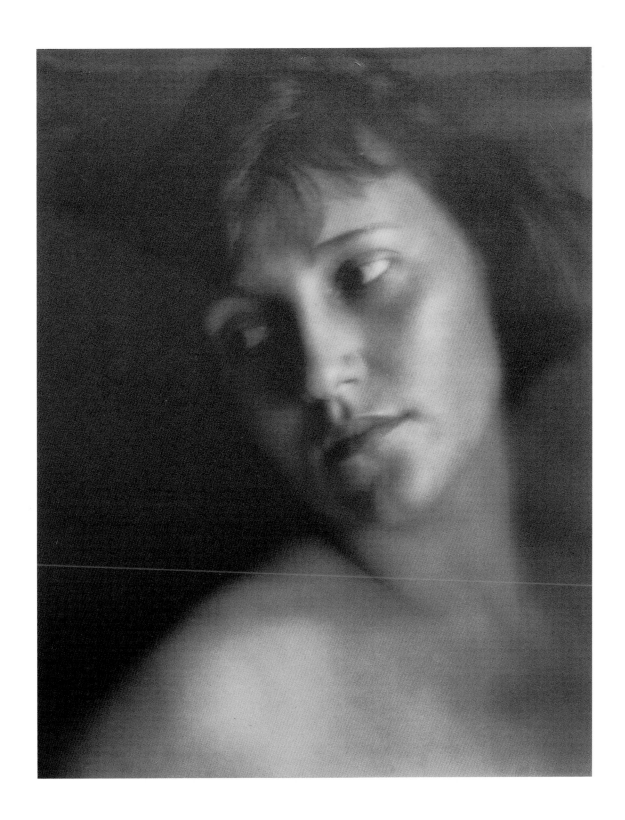

54. Margrethe Mather, *Florence Deshon*, 1921, platinum/palladium print.
Collection Mr. and Mrs. J. Kroin.

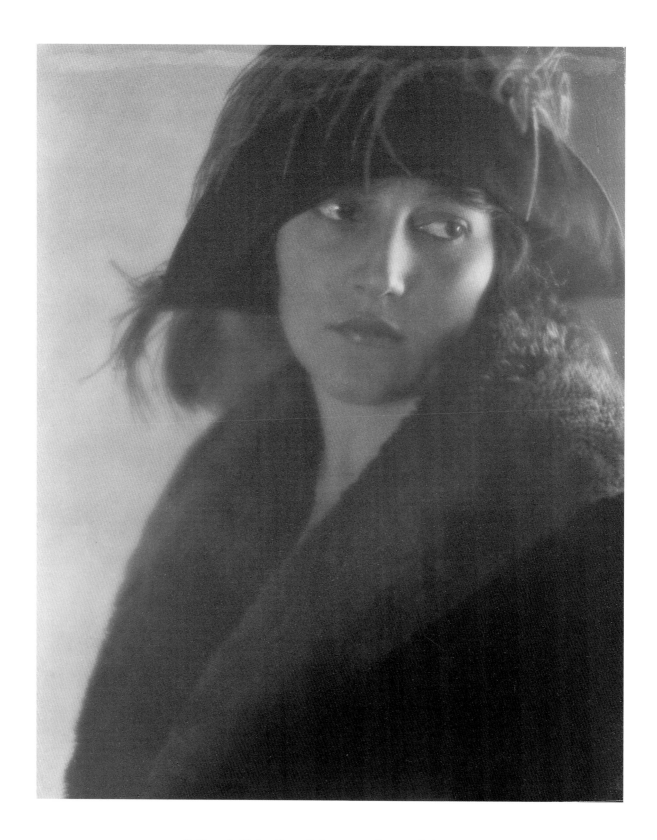

55. Margrethe Mather, *Florence Deshon*, ca. 1921, platinum/palladium print.
Collection Center for Creative Photography, University of Arizona, Tucson.

56. Edward Weston, *Imogen Cunningham*, 1922, platinum/palladium print.
Collection The J. Paul Getty Museum, Los Angeles.

57. Margrethe Mather, *Weston with Platinum Paper Rolls*, 1922, platinum/palladium print.
Courtesy George Eastman House, gift of Brett Weston.

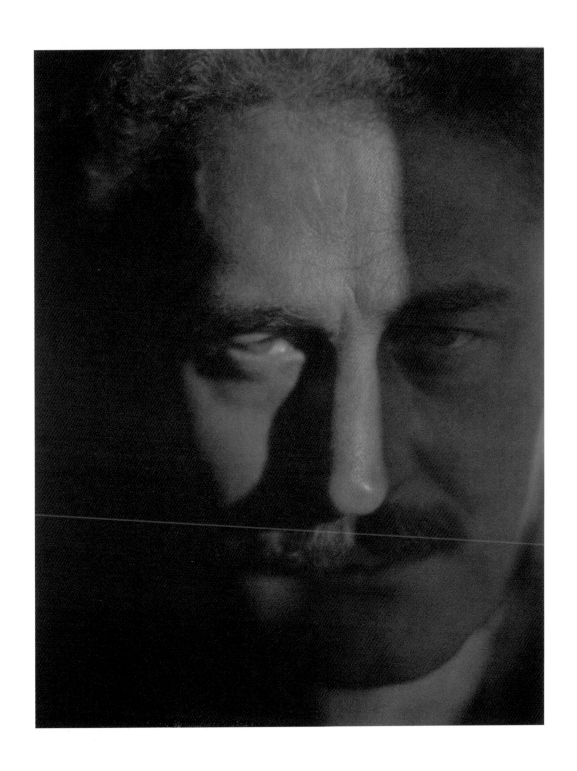

58. Margrethe Mather, *Richard Buhlig*, 1922, platinum/palladium print.
Collection National Museum of American History, Smithsonian Institution.

59. Margrethe Mather, *Dr. William F. Mack, Roentgenologist*, 1922, platinum/palladium print.
Collection National Museum of American History, Smithsonian Institution.

60. Edward Weston, *Karl Struss*, 1923, gelatin silver print.
Collection Michael and Jane Wilson.

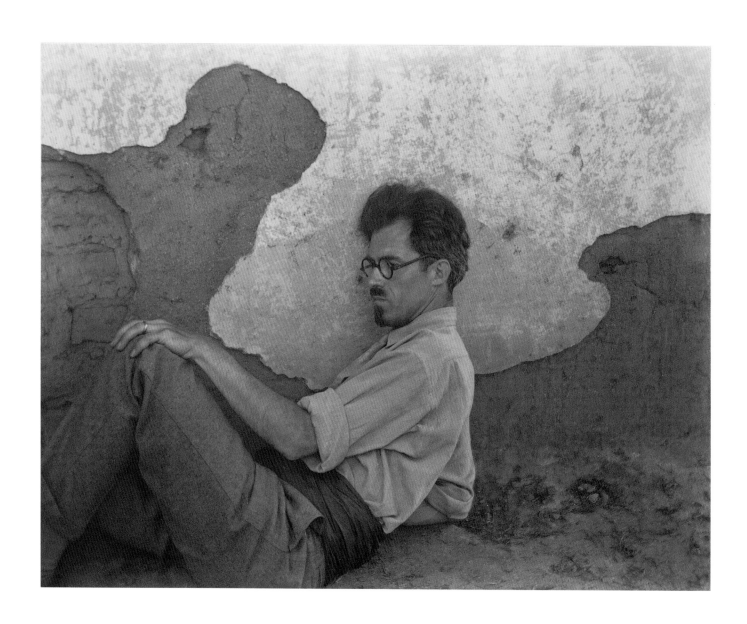

61. Edward Weston, *Roi Partridge*, 1922, platinum/palladium print.
Collection Gary B. Sokol.

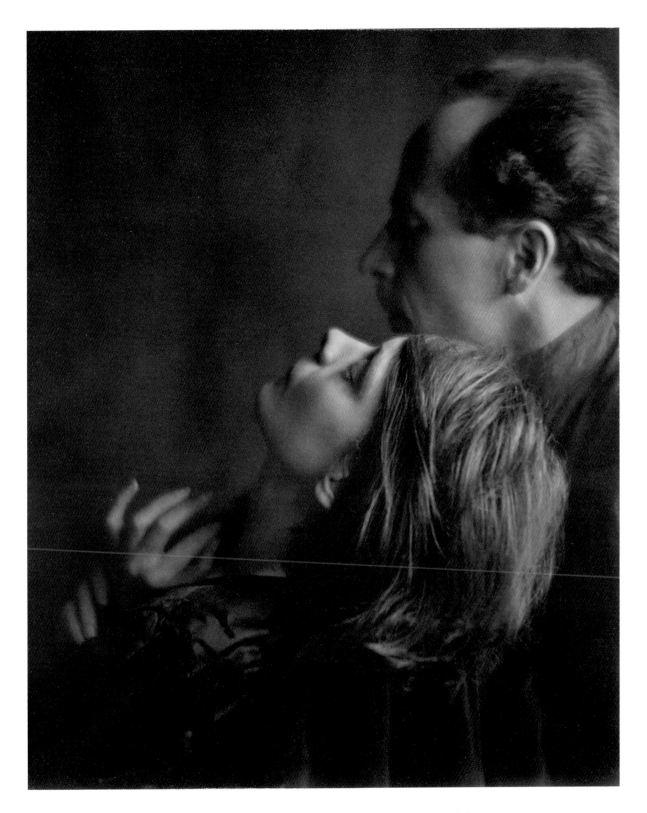

62. Imogen Cunningham, *Margrethe Mather and Edward Weston*, 1922, platinum/palladium print.
Courtesy George Eastman House.

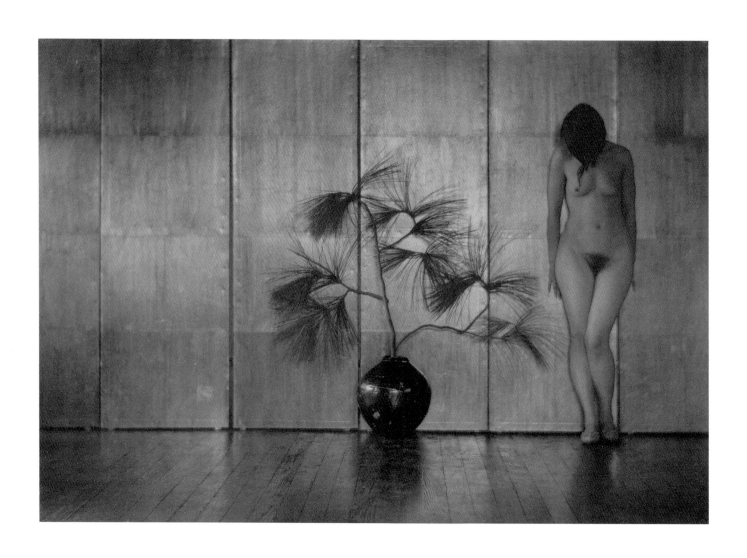

63. Edward Weston, *Nude and Pine Branch*, 1923, platinum/palladium print.
Collection David A. Dechman.

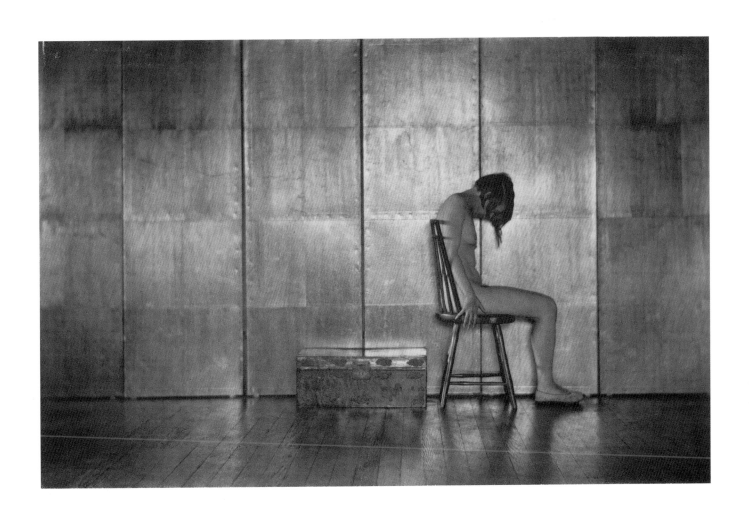

64. Edward Weston, *In My Glendale Studio*, 1923, platinum/palladium print.
The Lane Collection; courtesy Museum of Fine Arts, Boston.

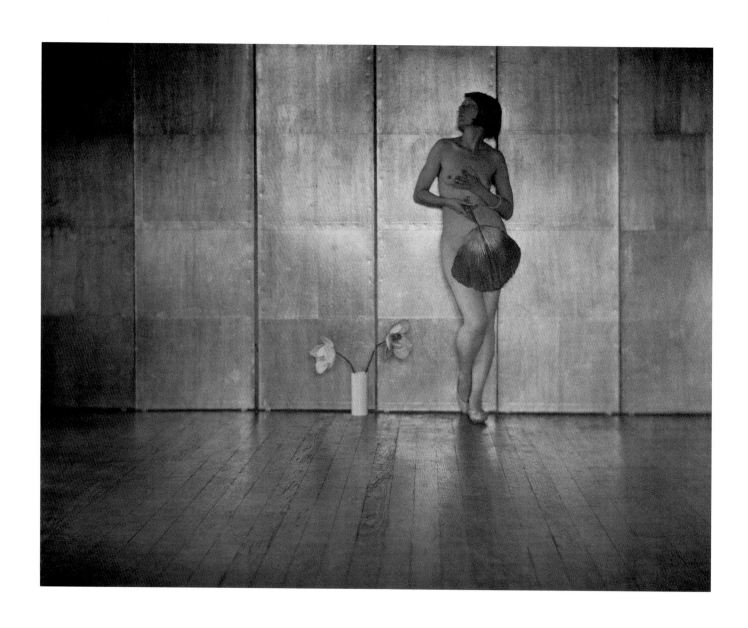

65. Edward Weston, *Margrethe Mather in Chinese Slippers with Feather Fan*, 1923, platinum/palladium print. Collection Center for Creative Photography, University of Arizona, Tucson. © 1981 Center for Creative Photography, Arizona Board of Regents.

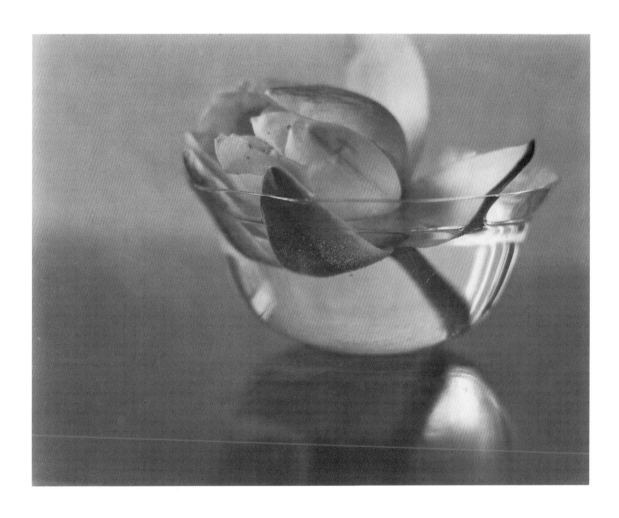

66. Margrethe Mather, *Water Lily*, 1922, platinum/palladium print.
The Lane Collection; courtesy Museum of Fine Arts, Boston.

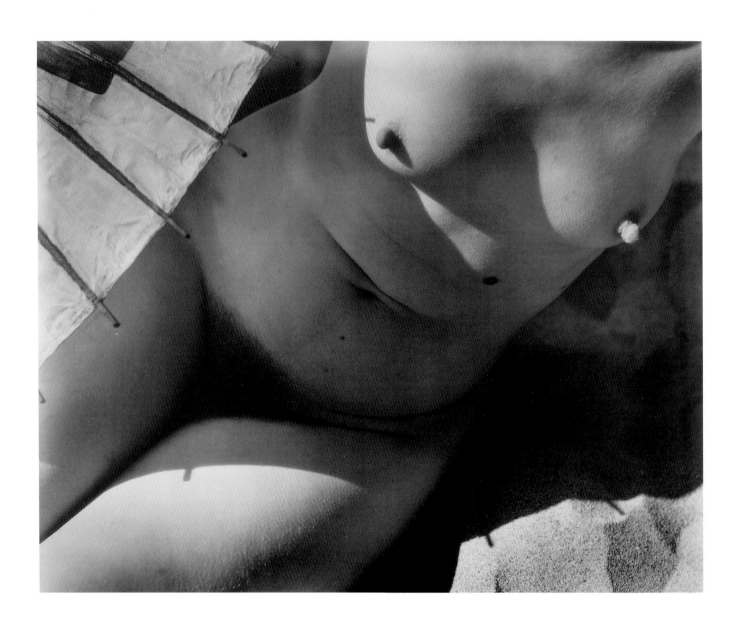

67. Edward Weston, *Margrethe Mather on Sand, Redondo Beach*, 1923, gelatin silver print. Collection Center for Creative Photography, University of Arizona, Tucson. © 1981 Center for Creative Photography, Arizona Board of Regents.

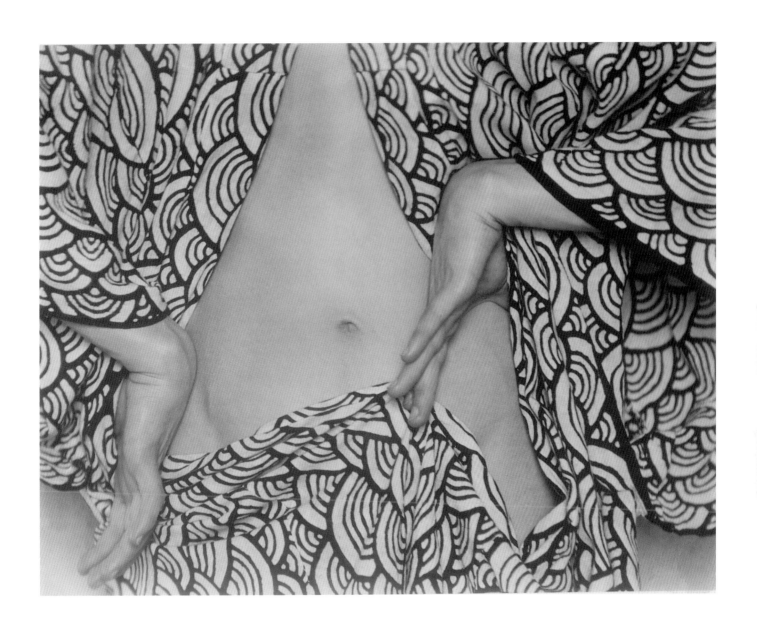

68. Margrethe Mather, *Semi-Nude* [Billy Justema Wearing Kimono], ca. 1923, gelatin silver print.
Collection Center for Creative Photography, University of Arizona, Tucson.

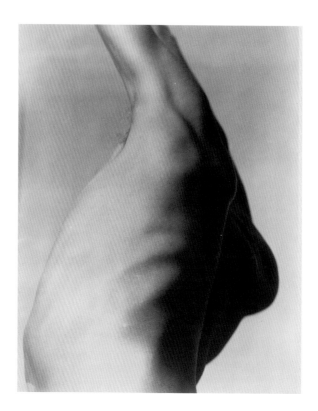

69. Margrethe Mather, Untitled [Billy Justema, Torso], ca. 1923, platinum/palladium print.
Collection Center for Creative Photography, University of Arizona, Tucson.

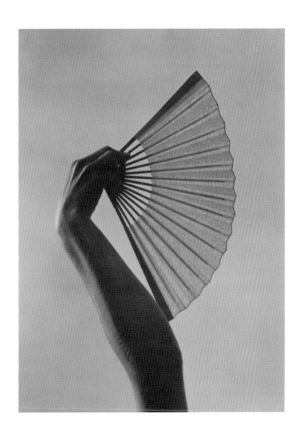

70. Margrethe Mather, *Fan in Hand*, ca. 1925, gelatin silver print.
Collection Center for Creative Photography, University of Arizona, Tucson.

71. Margrethe Mather, *The Abandoned Car*, ca. 1925, gelatin silver print.
Collection Center for Creative Photography, University of Arizona, Tucson.

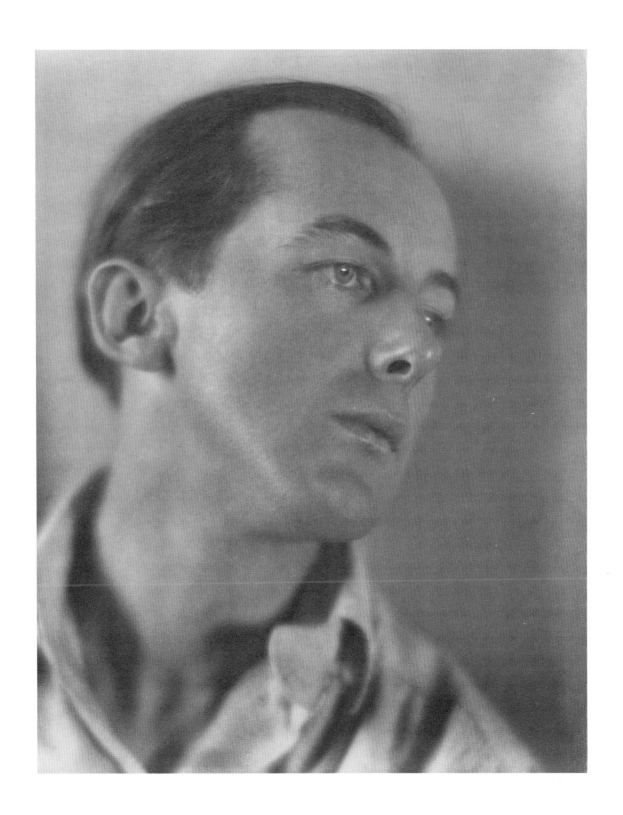

72. Margrethe Mather, *Henry Cowell*, 1923, platinum/palladium print.
Collection The J. Paul Getty Museum, Los Angeles.

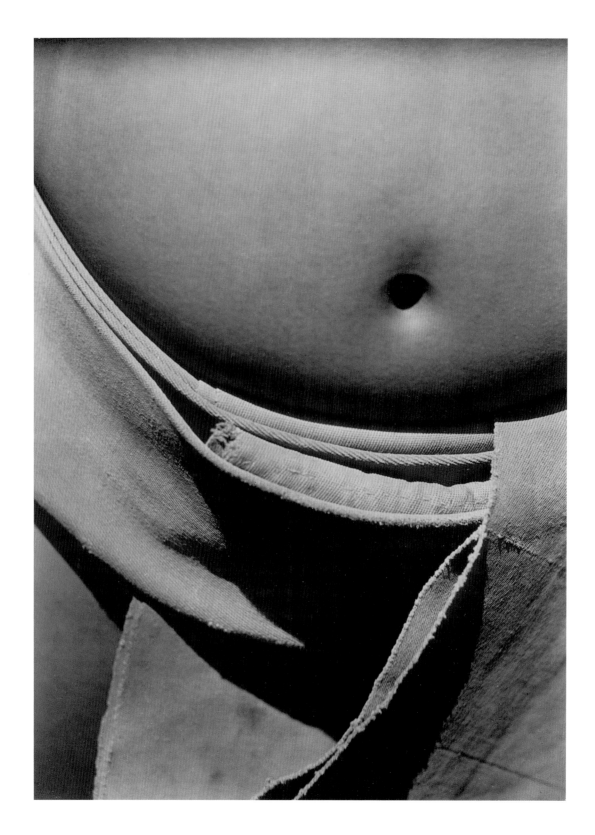

73. Margrethe Mather, *Japanese Wrestler's Belly*, 1927, gelatin silver print.
Collection Center for Creative Photography, University of Arizona, Tucson.

74. Margrethe Mather, *Circus Sideshow Critic*, 1927, gelatin silver print.
Collection Center for Creative Photography, University of Arizona, Tucson.

75. Margrethe Mather, *Wig from Chinese Opera*, 1927, gelatin silver print.
Collection Center for Creative Photography, University of Arizona, Tucson.

76. Margrethe Mather, *Still Life with Paper Parasol*, mid-1920s, platinum/palladium print.
Collection Center for Creative Photography, University of Arizona, Tucson.

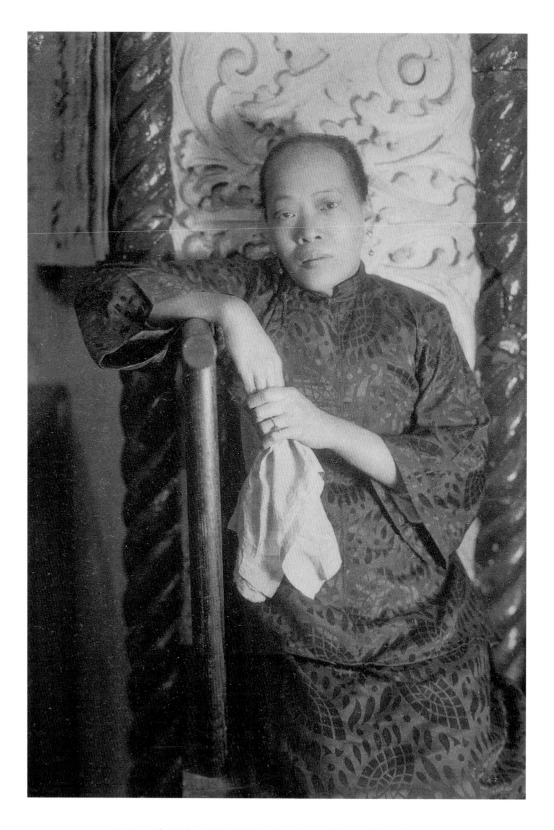

77. Margrethe Mather, *At the Old Chinese Opera Stage*, mid-1920s, gelatin silver print.
Collection Center for Creative Photography, University of Arizona, Tucson.

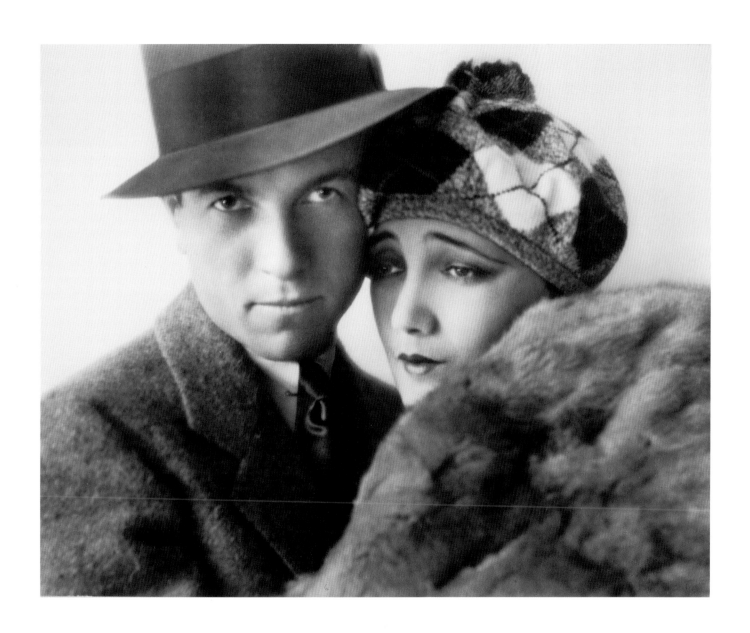

78. Margrethe Mather, *Harold Grieve and Jetta Goodall*, 1930, platinum/palladium print.
Collection Center for Creative Photography, University of Arizona, Tucson.

79. Margrethe Mather, *Bathroom Study*, 1927, gelatin silver print.
Collection Michael and Jane Wilson.

80. Margrethe Mather, *Residence of Blanche Sweet and Marshall Neilan*, 1927, gelatin silver print.
Collection Center for Creative Photography, University of Arizona, Tucson.

81. Margrethe Mather, *Hollyhock House*, ca. 1927, gelatin silver print.
Collection Library, Getty Research Institute, Los Angeles.

82. Margrethe Mather, *Iron Gate*, late 1920s, gelatin silver print.
Collection Michael and Jane Wilson.

83. Margrethe Mather, *Fans*, 1931, gelatin silver print.
Collection Center for Creative Photography, University of Arizona, Tucson.

84. Margrethe Mather, *Cherries on Type*, 1931, gelatin silver print.
Collection Center for Creative Photography, University of Arizona, Tucson.

85. Margrethe Mather, *Camel Cigarettes*, 1931, gelatin silver print.
Collection Center for Creative Photography, University of Arizona, Tucson.

86. Margrethe Mather, *Japanese Combs*, 1931, gelatin silver print.
Collection Center for Creative Photography, University of Arizona, Tucson.

87. Margrethe Mather, *Ticker Tape*, 1931, gelatin silver print.
Collection Center for Creative Photography, University of Arizona, Tucson.

88. Margrethe Mather, *Glass Eyes*, 1931, gelatin silver print.
Collection Center for Creative Photography, University of Arizona, Tucson.

89. Margrethe Mather, *Evening Gloves*, 1931, gelatin silver print.
Collection Center for Creative Photography, University of Arizona, Tucson.

1. Edward Weston, *Carlota*, 1914, platinum/palladium print, 1914. Collection John J. Medveckis.

2. Edward Weston, *Margrethe in Garden*, ca. 1915, platinum/palladium print. Collection Center for Creative Photography, University of Arizona, Tucson. © 1981 Center for Creative Photography, Arizona Board of Regents.

3. Edward Weston, *Nude with Black Shawl*, 1915, gelatin silver print. Courtesy Peter Fetterman Gallery.

4. Edward Weston, *The Fan—Margrethe Mather*, 1917, platinum/palladium print. Collection Center for Creative Photography, University of Arizona, Tucson. © 1981 Center for Creative Photography, Arizona Board of Regents.

5. Margrethe Mather, *Mollie Price Cook*, 1916, platinum/palladium print. Collection Mrs. Sirius C. Cook.

6. Margrethe Mather, *Maud Emily Taylor*, 1916, platinum/palladium print. Private collection.

7. Margrethe Mather, *Miss Maud Emily*, 1916, platinum/palladium print. Collection San Francisco Museum of Modern Art, gift of Nikki Avai and Simon Lowinsky in honor of John Humphrey.

8. Edward Weston, *Eugene Hutchinson*, 1916, medium unknown, reproduced from American Photography, July 1917. Collection Center for Creative Photography, University of Arizona, Tucson. © 1981 Center for Creative Photography, Arizona Board of Regents.

9. Margrethe Mather, *Frayne Williams as Hamlet*, ca. 1918, platinum/palladium print. Collection Jenifer Williams Angel.

10. Margrethe Mather, *Frayne Williams as Hamlet*, ca. 1918, platinum/palladium print. Collection Michael and Jane Wilson.

11. Margrethe Mather, *Alfred Kreymborg*, 1917, platinum/palladium print. Collection The J. Paul Getty Museum, Los Angeles.

12. Margrethe Mather, *Maud Emily Taylor Wearing Squash Blossom Necklace*, ca. 1918, platinum/palladium print. Private collection.

13. Margrethe Mather, *Maud Emily Taylor Seated in Chinese Chair*, ca. 1918, platinum/palladium print. Private collection.

14. Margrethe Mather, *Betty Katz with Rose*, ca. 1918, platinum/palladium print. Collection The J. Paul Getty Museum, Los Angeles.

15. Margrethe Mather, *Player on the Yit-Kim*, 1918, platinum/palladium print. Peil/Leonard Collection, courtesy Fraenkel Gallery.

16. Margrethe Mather, *Moon Kwan on the Yit-Kim*, 1918, platinum/palladium print. Collection Ella Strong Denison Library, Scripps College.

17. Edward Weston, *Epilogue*, ca. 1919, platinum/palladium print. Collection National Museum of American History, Smithsonian Institution.

18. Edward Weston, *Prologue to a Sad Spring*, ca. 1919, platinum/palladium print. Collection Leonard and Marjorie Vernon.

19. Margrethe Mather, *"Wild Joe" O'Carroll*, ca. 1919, platinum/palladium print. Collection Yvette Eastman.

20. Margrethe Mather, *Florence Deshon with Rose*, ca. 1919, platinum/palladium print. Collection Yvette Eastman.

21. Margrethe Mather, *Florence Deshon*, ca. 1919, platinum/palladium print. Collection Yvette Eastman.

22. Margrethe Mather, *Pointed Pines*, 1920, platinum/palladium print. Collection Metropolitan Museum of Art; purchase, Mr. and Mrs. Robert J. Massar; gift 1971. © 1999 The Metropolitan Museum of Art.

23. Edward Weston, *Margrethe in Glendale Studio*, ca. 1920, platinum/palladium print. Collection Center for Creative Photography, University of Arizona, Tucson. © 1981 Center for Creative Photography, Arizona Board of Regents.

24. Edward Weston, *Glendale Studio*, ca. 1920, platinum/palladium print. Collection Center for Creative Photography, University of Arizona, Tucson. © 1981 Center for Creative Photography, Arizona Board of Regents.

25. Edward Weston, *Margrethe Mather in Black Velvet*, ca. 1920, platinum/palladium print. Collection Center for Creative Photography, University of Arizona, Tucson. © 1981 Center for Creative Photography, Arizona Board of Regents.

26. Edward Weston, *Margrethe Mather on Horsehair Sofa*, n.d., platinum/palladium print. Collection Michael and Jane Wilson.

27. Edward Weston, *Betty in Her Attic*, 1920, platinum/palladium print. Collection The J. Paul Getty Museum, Los Angeles.

28. Edward Weston, *Ramiel in His Attic*, 1920, platinum/palladium print. Collection National Museum of American History, Smithsonian Institution.

29. Margrethe Mather, *Pierrot*, 1920, platinum/palladium print. Collection San Francisco Museum of Modern Art, gift of Elise S. Haas, in honor of Clifford R. Peterson.

30. Margrethe Mather, *Pierrot*, 1920, platinum/palladium print. Collection National Museum of American History, Smithsonian Institution.

31. Margrethe Mather, *Marionette*, ca. 1920, platinum/palladium print. Collection Hallmark Photographic Collection, Hallmark Cards, Inc.

32. Margrethe Mather, *Frayne Williams as Anatol*, 1920, platinum/palladium print. Collection Richard Shenk; courtesy Joel Soroka Gallery.

33. Margrethe Mather, *Reginald Poel* [Pole] *as Othello*, 1920, platinum/palladium print. Collection Jenifer Williams Angel.

34. Margrethe Mather, *Charles Gerrard with Waxed Moustache*, 1920, platinum/palladium print. Collection Bowdoin College Museum of Art, Brunswick, Maine; purchase, Lloyd O. and Marjorie Strong Coulter Fund.

35. Margrethe Mather, *Judith*, 1920, platinum/palladium print. Collection Center for Creative Photography, University of Arizona, Tucson.

36. Margrethe Mather and Edward Weston, *Carl Sandburg*, 1921, platinum/palladium print. Collection JGS, Inc.

37. Margrethe Mather and Edward Weston, *Max Eastman, Poet*, 1921, platinum/palladium print. Private collection; courtesy Sotheby's, Inc.

38. Margrethe Mather and Edward Weston, *Max Eastman on Beach*, 1921, platinum/palladium print. Collection The Museum of Modern Art.

39. Margrethe Mather and Edward Weston, *Max Eastman at Water's Edge*, 1921, platinum/palladium print. Private collection; courtesy Sotheby's, Inc.

40. Margrethe Mather and Edward Weston, *Max Eastman Seated on Railing*, 1921, platinum/palladium print. Collection The Museum of Modern Art.

41. Margrethe Mather and Edward Weston, *The Marion Morgan Dancers*, 1921, platinum/palladium print. Collection Sandor Family.

42. Margrethe Mather and Edward Weston, *The Marion Morgan Dancers*, 1921, platinum/palladium print. Collection Michael and Jane Wilson.

43. Margrethe Mather and Edward Weston, *Gjura Stojana*, 1921, platinum/palladium print. Collection The J. Paul Getty Museum, Los Angeles.

44. Edward Weston, *Japanese Fencing Mask*, 1921, platinum/palladium print. Collection Michael and Jane Wilson.

45. Edward Weston, *Head of an Italian Girl* [Tina Modotti], 1921, platinum/palladium print. Collection Michael and Jane Wilson.

46. Margrethe Mather, *Johan Hagemeyer and Edward Weston*, 1921, platinum/palladium print. Collection Center for Creative Photography, University of Arizona, Tucson.

47. Margrethe Mather, *Johan Hagemeyer*, 1921, platinum/palladium print. Collection Center for Creative Photography, University of Arizona, Tucson.

48. Margrethe Mather, *Edward Weston in Cape and Glasses*, ca. 1921, platinum/palladium print. Collection The Museum of Modern Art.

49. Margrethe Mather, *Edward Weston*, 1921, platinum/palladium print. Collection The J. Paul Getty Museum, Los Angeles.

50. Margrethe Mather, *Edward Weston*, 1921, platinum/palladium print. Courtesy George Eastman House, gift of Brett Weston.

51. Margrethe Mather, *Edward Weston*, 1921, platinum/palladium print. Collection Isaac Lagnado.

52. Margrethe Mather, *Florence Deshon with Fan*, 1921, platinum/palladium print. Collection Oakland Museum of Art, gift of Dr. and Mrs. Dudley P. Bell.

53. Margrethe Mather, *Nude with Shawl* [Florence Deshon], 1921, platinum/palladium print. Courtesy George Eastman House, museum purchase, ex-collection Mrs. Max Eastman.

54. Margrethe Mather, *Florence Deshon*, 1921, platinum/palladium print. Collection Mr. and Mrs. J. Kroin.

55. Margrethe Mather, *Florence Deshon*, ca. 1921, platinum/palladium print. Collection Center for Creative Photography, University of Arizona, Tucson.

56 Edward Weston, *Imogen Cunningham*, 1922, platinum/palladium print. Collection The J. Paul Getty Museum, Los Angeles.

57. Margrethe Mather, *Weston with Platinum Paper Rolls*, 1922, platinum/palladium print. Courtesy George Eastman House, gift of Brett Weston.

58. Margrethe Mather, *Richard Buhlig*, 1922, platinum/palladium print. Collection National Museum of American History, Smithsonian Institution.

59. Margrethe Mather, *Dr. William F. Mack, Roentgenologist*, 1922, platinum/palladium print. Collection National Museum of American History, Smithsonian Institution.

60. Edward Weston, *Karl Struss*, 1923, gelatin silver print. Collection Michael and Jane Wilson.

61. Edward Weston, *Roi Partridge*, 1922, platinum/palladium print. Collection Gary B. Sokol.

62. Imogen Cunningham, *Margrethe Mather and Edward Weston*, 1922, platinum/palladium print. Courtesy George Eastman House.

63. Edward Weston, *Nude and Pine Branch*, 1923, platinum/palladium print. Collection David A. Dechman.

64. Edward Weston, *In My Glendale Studio*, 1923, platinum/palladium print. The Lane Collection; courtesy Museum of Fine Arts, Boston.

65. Edward Weston, *Margrethe Mather in Chinese Slippers with Feather Fan*, 1923, platinum/palladium print. Collection Center for Creative Photography, University of Arizona, Tucson. © 1981 Center for Creative Photography, Arizona Board of Regents.

66. Margrethe Mather, *Water Lily*, 1922, platinum/palladium print. The Lane Collection; courtesy Museum of Fine Arts, Boston.

67. Edward Weston, *Margrethe Mather on Sand, Redondo Beach*, 1923, gelatin silver print. Collection Center for Creative Photography, University of Arizona, Tucson. © 1981 Center for Creative Photography, Arizona Board of Regents.

68. Margrethe Mather, *Semi-Nude* [Billy Justema Wearing Kimono], ca. 1923, gelatin silver print. Collection Center for Creative Photography, University of Arizona, Tucson.

69. Margrethe Mather, Untitled [Billy Justema, Torso], ca. 1923, platinum/palladium print. Collection Center for Creative Photography, University of Arizona, Tucson.

70. Margrethe Mather, *Fan in Hand*, ca. 1925, gelatin silver print. Collection Center for Creative Photography, University of Arizona, Tucson.

71. Margrethe Mather, *The Abandoned Car*, ca. 1925, gelatin silver print. Collection Center for Creative Photography, University of Arizona, Tucson.

72. Margrethe Mather, *Henry Cowell*, 1923, platinum/palladium print. Collection The J. Paul Getty Museum, Los Angeles.

73. Margrethe Mather, *Japanese Wrestler's Belly*, 1927, gelatin silver print. Collection Center for Creative Photography, University of Arizona, Tucson.

74. Margrethe Mather, *Circus Sideshow Critic*, 1927, gelatin silver print. Collection Center for Creative Photography, University of Arizona, Tucson.

75. Margrethe Mather, *Wig from Chinese Opera*, 1927, gelatin silver print. Collection Center for Creative Photography, University of Arizona, Tucson.

76. Margrethe Mather, *Still Life with Paper Parasol*, mid-1920s, platinum/palladium print. Collection Center for Creative Photography, University of Arizona, Tucson.

77. Margrethe Mather, *At the Old Chinese Opera Stage*, mid-1920s, gelatin silver print. Collection Center for Creative Photography, University of Arizona, Tucson.

78. Margrethe Mather, *Harold Grieve and Jetta Goodall*, 1930, platinum print. Collection Center for Creative Photography, University of Arizona, Tucson.

79. Margrethe Mather, *Bathroom Study*, 1927, gelatin silver print. Collection Michael and Jane Wilson.

80. Margrethe Mather, *Residence of Blanche Sweet and Marshall Neilan*, 1927, gelatin silver print. Collection Center for Creative Photography, University of Arizona, Tucson.

81. Margrethe Mather, *Hollyhock House*, ca. 1927, gelatin silver print. Collection Library Getty Research Institute, Los Angeles.

82. Margrethe Mather, *Iron Gate*, late 1920s, gelatin silver print. Collection Michael and Jane Wilson.

83. Margrethe Mather, *Fans*, 1931, gelatin silver print. Collection Center for Creative Photography, University of Arizona, Tucson.

84. Margrethe Mather, *Cherries on Type*, 1931, gelatin silver print. Collection Center for Creative Photography, University of Arizona, Tucson.

85. Margrethe Mather, *Camel Cigarettes*, 1931, gelatin silver print. Collection Center for Creative Photography, University of Arizona, Tucson.

86. Margrethe Mather, *Japanese Combs*, 1931, gelatin silver print. Collection Center for Creative Photography, University of Arizona, Tucson.

87. Margrethe Mather, *Ticker Tape*, 1931, gelatin silver print. Collection Center for Creative Photography, University of Arizona, Tucson.

88. Margrethe Mather, *Glass Eyes*, 1931, gelatin silver print. Collection Center for Creative Photography, University of Arizona, Tucson.

89. Margrethe Mather, *Evening Gloves*, 1931, gelatin silver print. Collection Center for Creative Photography, University of Arizona, Tucson.

Information for this essay was compiled during research for a soon-to-be-published biography of Edward Weston, Margrethe Mather, and the bohemians of Los Angeles.

1. Margrethe Mather to Edward Weston, 4 October 1950, Edward Weston Archive, Center for Creative Photography, University of Arizona, Tucson.

2. Nancy Newhall, introduction to *The Daybooks of Edward Weston, Mexico*, vol. 1, p. xvii.

3. *American Photography* (January 1913), opp. p. 20.

4. Mather to Weston, 4 October 1950.

5. This conclusion is based on manuscript notes made by Will Connell in which he outlined the history of the Camera Pictorialists. See Will Connell Archive, Special Collections, Research Library, University of California, Los Angeles.

6. "Camera Pictorialists of Los Angeles," *Camera Craft* (May 1914), p. 250; see also "Of Importance to Pictorialists," *Platinum Print* (May 1914), p. 12; "Society News," *American Photography* (May 1914), p. 319; *The Camera* (May 1914), p. 318.

7. George Cram Cook, ex-husband of Mather's friend Mollie Price Cook, had published *Roderick Taliaferro: A Story of Maximilian's Empire* in 1903. Cook's romance/adventure novel recounted a love story set against the historical backdrop of Maximilian's assassination.

8. *Carlota* was published as one example of Weston's work in his advertising brochure, printed in late 1914 or early 1915. It also appeared in *Studio Light* (July 1916), p. 7; in *Pacific Printer* (October 1916), frontispiece and p. 152; in *American Photography* (November 1916), p. 589; and Sadakichi Hartmann reviewed the photograph in "Looking for the Good Points," *The Bulletin* (November 1916), pp. 472–73. Weston exhibited the photograph in the Eleventh Salon, Toronto Camera Club, 27 April–2 May 1914; in the London Salon of Photography, autumn 1914; at the Northwest Photographers' Convention, spring 1915; in one-man exhibitions at the Shakespeare Club, Pasadena, March 1915, and at the State Normal School, Los Angeles, October–November 1915; in the Panama-Pacific Exposition, San Francisco, February–December 1915; and in the First Annual Arts and Crafts Salon held under the auspices of the Camera Pictorialists of Los Angeles, 4–27 February 1916.

9. *Photograms of the Year, 1915*, pl. 9.

10. *The Camera* (July 1916), p. 387.

11. This image was reproduced in Weston's advertising brochure, printed between May 1917 and November 1918, and exhibited in the Fifth Annual Pittsburgh Salon of Photography, 4–31 March 1918, and the Thirteenth Annual Exhibition of Photographs at the John Wanamaker Department Store, Philadelphia, 4–16 March 1918.

12. This image was reproduced in *American Photography* (July 1920), p. 389, and exhibited in the Seventh Annual Pittsburgh Salon of Photography, 3–31 March 1920.

13. This image was reproduced in *American Photography* (March 1921), p. 131, and included in one-man exhibitions at the Friday Morning Club, Los Angeles, June 1919, and at the State Normal School, Los Angeles, May 1920; in the First National Exhibition of Pictorial Photography held under the auspices of the Buffalo Camera Club, March 1920; and in the Society of Copenhagen Amateur Photographers 25th Anniversary Salon, 25 August–10 September 1920.

14. Quoted in William Justema, "Margaret: A Memoir," *Margrethe Mather* (1979), p. 19.

15. See birth records, Youngren/Jungren family Bible, Myrna Chadwick Collection.

16. Salt Lake City Directory, see Emma Youngren, 1903, and Emma Mather, 1904–6; Salt Lake High School transcripts, see Emma Younggreen, 1900–1901 and 1901–2, and Emma Youngren, 1902–3.

17. Thirteenth Federal Census, State of California, vol. 96, Enumeration District 234, Family Visitation Group 141, Margaret Mather [incorrectly indexed as Margaret Mother], 1291 Pine Street, San Francisco, 22 April 1910.

18. Twelfth Federal Census, State of California, vol. 12, Enumeration District 23, sheet 1, line 99, Elmer Ellsworth, 505½ S. Main Street, Los Angeles, 5 June 1900; Salt Lake City Business Directory, see Elmer Ellsworth, 1900–1902.

19. Mather to Weston, 4 October 1950.

20. The most prominent of these labor organizers was William "Big Bill" Haywood, who was elected secretary-treasurer of the Western Federation of Miners in 1900. (This organization became known as the International Union of Mine, Mill and Smelter Workers in the early teens.) The rugged labor leader originally hailed from the Salt Lake City area, where he had begun his working life as a cowboy and a miner. He went on to cofound the International Workers of the World (I.W.W., also known as the Wobblies) in Chicago in 1905. See Joseph R. Conlin, *Big Bill Haywood and the Radical Union Movement*, pp. 22 and 48. Mather was sympathetic to Haywood's left-wing causes, and probably knew him personally. In the late teens, she was part of a circle of people that included B.[eatrice] Shostac, a New York City schoolteacher known to have been Haywood's lover. See Hutchins Hapgood, *A Victorian in the Modern World*, p. 350, and Mabel Dodge Luhan, *Movers and Shakers*, pp. 186–87. Mather was quite familiar with the occupational hazards associated with mining. Both Mather's foster father, Joseph Cole Mather, and her brother, James Youngren, worked as smelters in the mining industry. In 1916 her brother died of pneumonia contracted while he was working in a mine near Salt Lake City. See James Youngren, death certificate, 20 November 1916, Salt Lake City, State of Utah.

21. This conclusion is based on letters from Emma Goldman to Dr. T. Perceval Gerson written on 28 May, 2 June, 8 June, and 17 July 1913, in which Ellsworth's role in securing Los Angeles venues for Goldman's annual cross-country lecture tours was discussed. See Dr. T. Perceval Gerson Papers, Special Collections, Research Library, University of California, Los Angeles. Goldman also thanked Ellsworth for his help in her publication *Mother Earth* in June 1912, p. 128; June 1913, p. 110; and August 1913, p. 173. Goldman again cited Elmer Ellsworth, and also Mollie Price [Cook], Dr. and Mrs. Gerson, and Margaret Mato [*sic*] as being the "most active" of her supporters during her recent stay in Los Angeles, *Mother Earth* (August 1914), p. 205.

22. "If Los Angeles had a bohemia, a Montmartre, a Soho, a Greenwich Village, or North Beach, Bunker Hill was it." Kevin Starr, *The Dream Endures: California Enters the 1940s*, p. 163.

23. Weston's paternal grandfather, Edward Payson Weston, was the first headmaster of Ferry Hall, an exclusive girls' finishing school in Lake Forest, Illinois. He went on to become the headmaster of Highland Hall, another girls' school in neighboring Highland Park, a position he held until his death. Weston's father, Edward Burbank Weston, was a well-known obstetrician and gynecologist, first in Highland Park and then in Chicago, where he maintained a private practice and lectured at Rush Medical College. Weston's mother's brother, Theodore Brett, was employed at Marshall Field's Department Store as a dry-goods salesman. It was through his Uncle Brett that Weston obtained his first job as a clerk at Marshall Field's. The young Weston gladly gave up his budding career in retail sales when he moved to California.

24. May Weston Seaman to Edward Weston, Weston Archive, CCP, quoted in Kathy Foley, *Edward Weston's Gifts to His Sister*, p. 17.

25. William Justema attested to Mather's sexual preferences, as did Weston in conversations with Nancy Newhall and Charis Wilson.

26. Weston's belief in pacifism is evident from reading his early correspondence to Johan Hagemeyer, Johan Hagemeyer Archive, Center for Creative Photography, University of Arizona, Tucson.

27. See Charles Chaplin, *Charles Chaplin: My Autobiography*, pp. 142–43.

28. See Los Angeles City Directory, 1913, where she was incorrectly listed as "Mary Mather, 306 S. Clay St.," and Los Angeles City Directory, 1915, where her name appeared in abbreviated form as "Margt. Mather, 306 S. Clay St."

29. See Los Angeles City Directory, 1913, where the Los Angeles Camera Club's address was given as "321 S. Hill St."

30. See Los Angeles City Directory, 1916, where she was listed as "Margrethe Mather, photog., 715 W. Fourth St." This listing reflected her recent relocation to the carriage house behind a large Victorian house known as the Hildreth home at the northwest corner of South Hope and West Fourth Streets.

31. Justema, "Margaret: A Memoir," p. 8.

32. Ibid.

33. Extensive correspondence, scrapbooks, and other documentation of Florence Reynolds's life can be found in the Florence Reynolds Papers,

Special Collections, University of Delaware Library, Newark.

34. See Los Angeles City Directories, 1916–29. In the 1922, 1923, and 1929 volumes, Mather described herself as an artist rather than a photographer.

35. *American Photography* (January 1913), opp. p. 20.

36. *American Photography* (November 1916), p. 601.

37. See Russell Coryell Scrapbooks, 1913–15, unpaginated, Stanis Coryell Collection.

38. See exhibition catalogue, Second Annual Pittsburgh Salon of National Photographic Art, 1–31 March 1915, wherein an unknown photograph by Margrethe Mather entitled *The Menace* is listed.

39. *American Photography* (January 1913), opp. p. 20.

40. Ibid.; *Camera Craft* (September 1912), p. 433; *Photo-Era* (March 1913), p. 145.

41. See exhibition brochure, Salon International d'Art Photographique, Ghent, Belgium, 27 April–November 1913, entry 441; *Photo-Era* (August 1912), p. 87.

42. See Russell Coryell Scrapbooks, unpaginated.

43. This information is gleaned from correspondence between Maud Emily Taylor and Russell Coryell, 1914–17, Maud Emily (Taylor) Glass Papers, Special Collections, Research Library, University of California, Los Angeles.

44. See Los Angeles City Directory, 1914–15, where she is listed as "Mollie Price Cook, Director & Principal, The Children's House, a Montessori School, In and Out-of-Doors, 2319 Ocean Ave."

45. *American Photography* (November 1916), p. 601.

46. See Arthur Wesley Dow, *Composition*.

47. Whistler's influence on Weston was discussed on several occasions by the *Los Angeles Times* art critic Antony Anderson in his weekly column, "Of Art and Artists." See, in particular, *Los Angeles Times*, 1 June 1923, sec. 3, p. 26; and 29 July 1923, sec. 3, p. 22.

48. *Photograms of the Year, 1917–18*, pl. 59.

49. The information regarding Mather's many connections with *The Little Review* was gathered from a variety of sources, including: Alfred Kreymborg, *Troubadour: An Autobiography*; Alfred Kreymborg, ed., *Others for 1919*, p. 149; Margaret Anderson, *My Thirty Years' War: An Autobiography*; Elsie Whitaker Martinez, recorded interview, Regional Oral History Office, Bancroft Library, University of California, Berkeley; Paul Jordan-Smith, *The Road I Came*; Jenifer Angel, recorded interview with author; and Norman and Dorothy Karasick, *The Oilman's Daughter: A Biography of Aline Barnsdall*.

50. Weston's trip to Cleveland was discussed in *Camera Craft* (April 1916), p. 66; *Photo-Era* (April 1916), p. 203; *Camera Craft* (June 1916), p. 251; and *Photo-Era* (September 1916), p. 143.

51. Anderson's portrait by Hutchinson is preserved in *The Little Review* archive, Special Collections, University of Wisconsin, Milwaukee; for his portrait of Goldman, see *My Thirty Years' War: An Autobiography*, opp. p. 54; for his portrait of Brooke, see *The Little Review* (June–July 1915), p. 33.

52. *American Photography* (July 1917), p. 383.

53. This image was reproduced in *The Camera* (April 1917), p. 179; *Camera Craft* (November 1917), p. 460; and *Photograms of the Year, 1917–18*, pl. 23.

54. This portrait was reproduced in *Platinum Print* (October 1917), p. 54; and *Camera Craft* (March 1919), p. 92.

55. This portrait was reproduced in *American Annual of Photography, 1921*, p. 263.

56. See Friday Morning Club Scrapbooks, unidentified newspaper clippings, vol. 4, pp. 208, 211.

57. For information regarding Williams's role in Barnsdall's theatrical company, see Karasick, *The Oilman's Daughter*, p. 52; *Los Angeles Times*, 16 November 1916, sec. 3, p. 1; *Los Angeles Times*, 24 December 1916, sec. 3, p. 1.

58. See Karasick, *The Oilman's Daughter*, pp. 24–25.

59. See Roy Rosen to Lawrence Jasud, 24 October 1980, Roy Rosen Archive, University of New Mexico, Santa Fe.

60. Information about Betty Katz came from papers and correspondence, Martin Lessow Collection.

61. An entry in Hagemeyer's diaries establishes Mather's presence in Weston's studio on 8 February 1918. In all likelihood, however, Mather was spending time there as early as 1913.

62. See Hagemeyer Diaries, entries for March–June 1918, Hagemeyer Archive, CCP.

63. See Robert K. Murray, *Red Scare: A Study in National Hysteria, 1919–1920*, for a discussion of post–World War I American politics and attitudes.

64. See Hagemeyer Diaries, entries for 1920, Hagemeyer Archive, CCP.

65. Interview with Charis Wilson, 4 November 1997. See also Charis Wilson and Wendy Madar, *Through Another Lens: My Years with Edward Weston*, p. 43.

66. A. T. DeRome, "A Few Pictures Reviewed," *Camera Craft* (March 1919), p. 93.

67. *American Photography* (September 1919), p. 493.

68. Frank Roy Fraprie, "Our Illustrations," *American Photography* (September 1919), p. 547.

69. Although other scholars have assigned *Epilogue* to 1918, based on an example at the National Museum of American History that is signed and dated "1918" by Weston, all other known prints of the image are signed and dated "1919." The example at NMAH was sent to that institution by Weston in 1923, suggesting that Weston may have incorrectly remembered the negative date when he inscribed the NMAH example. *Epilogue* was first reproduced in *Photograms of the Year, 1919*, which was published in early 1920, and first exhibited in March 1920 at the Fourteenth Annual Exhibition of Photographs at the John Wanamaker Department Store in Philadelphia. (See exhibition brochure, Fourteenth Annual Exhibition of Photographs, John Wanamaker Department Store, Philadelphia, 1–13 March, 1920, unpaginated.) Because Weston was usually quick to publish and/or exhibit his most recent work, these dates lend further credence to the theory that *Epilogue* was probably not taken before late 1919. *Prologue to a Sad Spring* was first shown in May 1920 in a one-man exhibition at the State Normal School in Los Angeles. (See *Los Angeles Times*, 15 May 1920, sec. 3, p. 2.)

70. Wilfred A. French, "Our Illustrations," *Photo-Era* (August 1920), p. 96.

71. See "I. W. W. Army Riots in Cooper Union, Host of 300 Invades Socialist Symposium on Problem of Unemployed, Flying Wedge on Stage, Joseph O'Carroll, I. W. W. Leader, Attacks Socialists Who Try to Silence Him—Two Arrests Made," *New York Times*, 20 March 1914, sec. 1, p. 1.

72. See Weston to Hagemeyer, 11 December 1919, 21 December 1919, 13 April 1920, and 19 May 1920, Hagemeyer Archive, CCP.

73. See William L. O'Neill, *The Last Romantic: A Life of Max Eastman*, p. 81.

74. See Florence Deshon to Max Eastman, 26 December 1919, Max Eastman Papers, Lily Library, Indiana University, Bloomington; Weston to Hagemeyer, 28 July 1921, Hagemeyer Archive, CCP.

75. See exhibition brochure, Seventh Annual Pittsburgh Salon of Photography, Carnegie Institute, Pittsburgh, 3–31 March 1920, unpaginated.

76. "Photo Pictorialists Honored," *Photo-Era* (June 1920), p. 48.

77. "Boston Y.M.C.A. Camera Club," *Camera Craft* (November 1919), p. 447; "Announcing a Series of Pictorial Photography 1919–1920," *American Photography* (December 1919), p. 746.

78. See exhibition brochure, Fourteenth Annual Exhibition of Photographs, John Wanamaker Department Store, Philadelphia, 1–13 March 1920, unpaginated; *Camera Craft* (June 1919), p. 288.

79. See exhibition brochure, First Annual Frederick & Nelson [Department Store] Salon, Seattle, 1–13 November 1920, unpaginated.

80. See Edward Weston to Betty Katz, October 1920–March 1921, Weston Archive, CCP.

81. *Ramiel in His Attic* and *Betty in Her Attic* (or *Attic Arrangement*, another image of Katz) were exhibited together at the Friday Morning Club, Los Angeles, in February 1921; the First Annual Exhibition of Pictorial Photographs, Kansas City, 26 February–12 March 1921; and the Fifteenth Annual Exhibition of Photographs, John Wanamaker Department Store, Philadelphia, 7–26 March 1921.

82. *Ascent of Attic Angles* was exhibited, possibly for the first time, at the Frederick & Nelson [Department Store] Second Annual Exhibition of Pictorial Photography, Seattle, 1–12 November 1921.

83. *Sunny Corner in an Attic* was exhibited, possibly for the first time, at the First Annual International Exhibition of Pictorial Photography under the direction of the Pictorial Photographic Society of San Francisco, Palace of Fine Arts, San Francisco, 20 May–18 June 1922.

84. The first of the Pierrot images to be exhibited was entitled *Pierrot's Death*. It was included in the

Twenty-Fifth Anniversary Salon of the Copenhagen Photographic Amateur Club, 25 August–10 September 1920. Variants also appeared in the exhibition of the First Annual Competition organized by *American Photography*, which traveled throughout 1921; in the Eighth Annual Pittsburgh Salon of Photography, Carnegie Institute, 2–31 March 1921; and in the First Annual Salon of Pictorial Photography, San Diego Museum Art Galleries, 15 April–15 May 1921. The most refined of these variants was illustrated in *American Photography* (September 1921), p. 471.

85. See Kreymborg, *Troubadour*, pp. 354–55.

86. See Sarah M. Lowe, *Tina Modotti Photographs*, pl. 113.

87. Biographical information about Frayne Williams came from an interview with his daughter Jenifer Angel and from his papers and scrapbooks, which are in her possession; see also Jordan-Smith, *The Road I Came*, pp. 378–86, for his descriptions of Williams and Reginald Pole, as well as Elmer Ellsworth and Charlie Chaplin.

88. See Jordan-Smith, *The Road I Came*, pp. 378–83.

89. Edgar Felloes, "The Oakland Salon," *Camera Craft* (November 1921), p. 361.

90. F. C. Tilney, "Pictorial Photography in 1921," *Photograms of the Year, 1921*, p. 17.

91. Imogen Cunningham to Edward Weston, 27 July 1920, Weston Archive, CCP.

92. See Tina Modotti to Edward Weston, fragments from EW's pre-1923 daybooks, quoted in Amy Stark, ed., *The Letters from Tina Modotti to Edward Weston*, p. 10.

93. Antony Anderson, "Of Art and Artists" column, *Los Angeles Times*, 13 February 1921, sec. 3, p. 2.

94. See Max Eastman, *Love and Revolution: My Journey Through an Epoch*, p. 172.

95. See ibid., pp. 245–46; "Clews Sought in Death Case," *Los Angeles Times*, 6 February 1922, sec. 2, pp. 1 and 6; "Eastman Denies Rift with Miss Deshon," *New York Times*, 6 February 1922, sec. 1, p. 3; "Miss Deshon Buried, Writer Vainly Gives Blood for Transfusion," *New York Times*, 7 February 1922, sec. 1, p. 2.

96. See Weston to Hagemeyer, 6 March 1922, wherein Weston refers to Deshon's death and "M's very low condition," Hagemeyer Archive, CCP.

97. See Weston to Hagemeyer, 13 February 1922, wherein Weston writes "Robo died from Smallpox in Mexico City . . . ," Hagemeyer Archive, CCP; see also Sarah M. Lowe, *Tina Modotti Photographs*, pp. 20–21.

98. See Weston to Hagemeyer, 13 February, 23 February, and 6 March 1922, Hagemeyer Archive, CCP.

99. There is evidence of Mather's participation in only three exhibitions during 1922. In the first of these, held at the MacDowell Club, 19 March–14 April, Los Angeles, the only photographs by Mather were those portraits she had produced jointly with Weston the previous year, but, on this occasion, Weston alone was credited as their maker. The other two exhibitions in which Mather's work was shown were the Sixth International Salon of Photography, held under the auspices of the Camera Pictorialists, 20 November–11 December, Los Angeles; and the International Exhibition of the London Salon of Photography, 9 September–7 October 1922.

100. See Florence Reynolds Papers, Special Collections, University of Delaware, Newark, for information on Reynolds's sister and brother-in-law, Hattie Reynolds Mack and Dr. William F. Mack.

101. Antony Anderson, "Of Art and Artists" column, *Los Angeles Times*, 23 July 1922, sec. 3, p. 43.

102. Imogen Cunningham, transcribed interviews with Margery Mann, 1960–73, microfilm reel 5051, Archives of American Art, unpaginated.

103. Weston, *Daybooks, Mexico*, p. 27.

104. Ibid.

105. Ibid., p. 26.

106. See tax records for 1315 South Brand Boulevard, Glendale, Los Angeles County Archives.

107. See eviction notices with notations in Flora Weston's handwriting, and Modotti to Weston, 28 December 1924, Weston Archive, CCP.

108. Weston, *Daybooks, Mexico*, p. 145.

109. Justema, "Margaret: A Memoir," p. 5.

110. See William Justema, death certificate, 7 January 1987, San Francisco, State of California.

111. See William Justema to Dennis Reed, 23 May 1983, Dennis Reed Collection.

112. See Will Connell, "The Camera Pictorialists of Los Angeles," *The Pictorialist*, pp. 4–5.

113. See exhibition brochure produced under the auspices of the *Los Angeles Japanese Daily News*, 1924, unpaginated, Dennis Reed Collection.

114. Antony Anderson, "Of Art and Artists" column, "The Artistry of Margrethe Mather," *Los Angeles Times*, 18 May 1924, sec. 3, p. 32.

115. Mather's substance-abuse problems are discussed in Justema, "Margaret: A Memoir," p. 17.

116. See Mather to Weston, August 1927, Weston Archive, CCP.

117. See transcription of Mather and Justema's Guggenheim grant application submitted to the 1929 competition, John Simon Guggenheim Memorial Foundation Archives, New York City.

118. Ibid.

119. Weston, *Daybooks, California*, p. 21.

120. See Justema, "Margaret: A Memoir," pp. 17–19. There is additional evidence to confirm her longstanding relationship with George Lipton in correspondence preserved in the Sadakichi Hartmann Archive, University of California, Riverside; the Rosen Archive, UNM; the Katz Papers, Martin Lessow Collection; and the Weston Archive, CCP.

121. See Weston to Hagemeyer, 18 March 1929, Weston Archive, CCP.

122. See "Opening of Museum Wing Nears," *San Francisco Chronicle*, 12 July 1931, sec. D, p. 8.

123. "New Galleries at Museum to be Opened," *San Francisco Chronicle*, 14 July 1931, p. 3.

124. See Edward Steichen, *A Life in Photography*, chap. 7, unpaginated, and pls. 109–12.

125. See Weston, *Daybooks, California*, p. 218.

126. Ibid., pp. 264–65.

127. See Sadakichi Hartmann to Wistaria Hartmann Linton, 18 January 1939, Hartmann Archive, UC Riverside.

128. See Justema, "Margaret: A Memoir," p. 19; Margaret Lipton [Margrethe Mather], death certificate, 25 December 1952, Los Angeles, State of California.

129. See Los Angeles City Directories and telephone books, 1928–52; Glendale City Directories, 1930–50.

130. See tax records for 357 South Hope Street, Los Angeles County Archives.

131. See Margaret Lipton [Margrethe Mather], death certificate.

132. See Edward Weston, death certificate, 1 January 1958, Carmel, State of California.

Selected Bibliography

BOOKS AND ARTICLES

Anderson, Margaret. *My Thirty Years' War: An Autobiography*. New York: Covici, Friede, 1930.

Beard, Rick, and Leslie Cohen Berlowitz, eds. *Greenwich Village: Culture and Counterculture*. New York: Museum of the City of New York, 1993.

Bunnell, Peter C., and David Featherstone, eds. *EW 100: Centennial Essays in Honor of Edward Weston, Untitled 41*. With essays by Robert Adams, Amy Conger, Andy Grundberg, Therese Thau Heyman, Estelle Jussim, Alan Trachtenberg, Paul Vanderbilt, Mike Weaver, and Charis Wilson. Carmel, Calif.: Friends of Photography, 1986.

Chaplin, Charles. *Charles Chaplin: My Autobiography*. New York: Simon & Schuster, 1964.

Clayton, Douglas. *Floyd Dell: Life and Times of an American Rebel*. Chicago: Ivan R. Dee, 1994.

Comer, Virginia. *Angels Flight: A History of Bunker Hill's Incline Railway*. Los Angeles: Historical Society of Southern California, 1996.

Conger, Amy. *Edward Weston in Mexico*. Albuquerque: University of New Mexico Press, 1983.

———. *Edward Weston: Photographs from the Collection of the Center for Creative Photography*. Tucson: Center for Creative Photography, University of Arizona, 1992.

Conlin, Joseph R. *Big Bill Haywood and the Radical Union Movement*. Syracuse, N.Y.: Syracuse University Press, 1968.

Cook, George Cram. *Roderick Taliaferro: A Story of Maximilian's Empire*. New York: Macmillan, 1903.

Connell, Will, James N. Doolittle, and Karl Struss, eds. *The Pictorialist, 1931*. Los Angeles: Camera Pictorialists of Los Angeles, 1931.

Danly, Susan, and Weston J. Naef. *Edward Weston in Los Angeles*. San Marino, Calif.: Huntington Library and Art Gallery, 1986.

Dell, Floyd. *Homecoming: An Autobiography*. New York: Farrar & Rinehart, 1933.

Dimock, George. "Edward Weston's Anti-Puritanism," *History of Photography*, Spring 2000, pp. 65–74.

Dow, Professor Arthur Wesley. *Composition: A Series of Exercises in Art Structure for the Use of Students and Teachers*. 1899. New York: Doubleday, Page & Co.; reprint, 1914.

Eastman, Max. *Love and Revolution: My Journey Through an Epoch*. New York: Harper & Row, 1964.

Foley, Kathy Kelsey. *Edward Weston's Gifts to His Sister*. Dayton, Ohio: Dayton Art Institute, 1978.

Gebhard, David, Harriette von Breton, and Robert W. Winter. *Samuel and Joseph Cather Newsom: Victorian Architectural Imagery in California, 1879–1908*. With photographs by Marvin Rand. Santa Barbara: Regents of the University of California, 1979.

Goldman, Emma. *Living My Life*. New York: Alfred A. Knopf, 1931.

Green, Nancy E., and Jessie Poesch. *Arthur Wesley Dow and the American Arts & Crafts*. New York: American Federation of Arts, in association with Harry N. Abrams, 1999.

Hapgood, Hutchins. *A Victorian in the Modern World*. New York: Harcourt, Brace & Co., 1939.

Haywood, William. *Bill Haywood's Book: the Autobiography of Big Bill Haywood*. New York: International Publishers, 1929.

Henderson, G. C., and Robert A. Oliver. *Tropico: The City Beautiful*. With photographs by Edward Weston. Tropico, Calif.: Knights of Pythias, 1914.

Hooks, Margaret. *Tina Modotti, Photographer and Revolutionary*. New York: Pandora/HarperCollins, 1993.

Hylen, Arnold. *Bunker Hill—A Los Angeles Landmark*. Los Angeles: Dawson's Book Shop, 1976.

———. *Los Angeles Before the Freeways, 1850–1950: Images of an Era*. Los Angeles: Dawson's Book Shop, 1981.

Jordan-Smith, Paul. *The Road I Came*. Caldwell, Idaho: Caxton Printers, 1960.

Justema, William, and Lawrence Jasud. *Margrethe Mather*. Catalogue no. 11. Tucson: Center for Creative Photography, University of Arizona, 1979.

Karasick, Dorothy K. and Norman M. *The Oilman's Daughter: A Biography of Aline Barnsdall*. Encino, Calif.: Carleston Publishing, 1993.

Klein, Norman. *The History of Forgetting: Los Angeles and the Erasure of Memory*. London: Verso Press, 1997.

Kreymborg, Alfred. *Troubadour: An Autobiography*. New York: Boni & Liveright, 1925.

————, ed. *Others for 1919: An Anthology of the New Verse*. New York: Nicholas Brown, 1920.

Lorenz, Richard, John P. Schaefer, and Terence R. Pitts. *Johan Hagemeyer*. The Archive, Research Series, no. 16. Tucson: Center for Creative Photography, University of Arizona, 1982.

Lowe, Sarah M. *Tina Modotti Photographs*. New York and Philadelphia: Harry N. Abrams, Inc., in association with the Philadelphia Museum of Art, 1995.

Luhan, Mabel Dodge. *Movers and Shakers*. New York: Harcourt, Brace & Co., 1936.

Lynn, Kenneth. *Charlie Chaplin and His Times*. New York: Simon & Schuster, 1997.

Maddow, Ben. *Edward Weston: His Life*. New York: Aperture, 1989.

McPherson, Beth Ann and Tommy. *Arthur Wesley Dow and His Influence upon the Arts and Crafts Movement in America*. Berkeley, Calif.: Arts and Crafts Press, 1999.

McWilliams, Carey. *Southern California Country: An Island in (on) the Land*. Edited by Erskine Caldwell. New York: Duell, Sloan & Pearce, 1946.

Milton, Joyce. *Tramp: The Life of Charlie Chaplin*. New York: HarperCollins, 1996.

Mora, Gilles, ed. *Edward Weston: Forms of Passion*. With essays by Gilles Mora, Terence Pitts, Trudy Wilner Stack, Theodore E. Stebbins, Jr., and Alan Trachtenberg. New York: Harry N. Abrams, 1995.

Murray, Robert K. *Red Scare: A Study in National Hysteria, 1919–1920*. New York: McGraw-Hill, 1955.

Myers, Roger, and Judith Leckrone, comps. *Johan Hagemeyer Collection*, Guide Series, no. 11. Tucson: Center for Creative Photography, University of Arizona, 1985.

Newhall, Beaumont, and Amy Conger, eds. *Edward Weston Omnibus*. Salt Lake City, Utah: Peregrine Smith Books, 1984.

O'Neill, William L. *The Last Romantic: a Life of Max Eastman*. New York: Oxford University Press, 1978.

Peterson, Christian A. *After the Photo-Secession: American Pictorial Photography, 1910–1955*. New York: Minneapolis Institute of the Arts, in association with W. W. Norton & Co., 1997.

Reed, Dennis. *Japanese Photography in America, 1920–1940*. Los Angeles: Japanese American Cultural & Community Center, 1986.

————, and Michael Wilson. *Pictorialism in California: Photographs, 1900–1940*. Malibu and San Marino, Calif.: J. Paul Getty Museum and Henry E. Huntington Library and Art Gallery, 1994.

Stark, Amy, ed. *The Letters from Tina Modotti to Edward Weston*. The Archive, Research Series, no. 22. Tucson: Center for Creative Photography, University of Arizona, 1986.

Starr, Kevin. *Americans and the California Dream, 1850–1915*. New York: Oxford University Press, 1973.

————. *Material Dreams: Southern California through the 1920s*. New York: Oxford University Press, 1990.

————. *The Dream Endures: California Enters the 1940s*. New York: Oxford University Press, 1997.

Stebbins, Theodore, Jr. *Weston's Westons: Portraits and Nudes*. Boston and New York: Museum of Fine Arts, Boston, in association with Bulfinch Press/Little, Brown & Co., 1989.

————, with Karen Quinn and Leslie Furth. *Edward Weston: Photography and Modernism*. Boston and New York: Museum of Fine Arts, Boston, in association with Bulfinch Press/Little, Brown & Co., 1999.

Steichen, Edward. *A Life in Photography*. New York: Doubleday & Co., 1963.

Weston, Edward. *The Daybooks of Edward Weston*. Edited by Nancy Newhall. *Mexico*, vol. 1. Rochester, N.Y.: George Eastman House, 1961. *California*, vol. 2. New York: Horizon Press, in collaboration with George Eastman House, 1966.

Wilson, Charis. *Edward Weston Nudes*. Millerton, N.Y.: Aperture, 1977.

————, and Wendy Madar. *Through Another Lens: My Years with Edward Weston*. New York: North Point Press, 1998.

PERIODICALS, NEWSPAPERS, EXHIBITION CATALOGUES, AND BROCHURES

American Annual of Photography, January 1910–December 1923.

American Journal of Photography, January 1910–December 1920.

American Photography, January 1910–December 1923.

The Bulletin, November 1916.

The Camera, January 1910–December 1923.

Camera Craft, January 1910–August 1930.

The First Annual Catalogue of the Young Ladies' Seminary, at "Ferry Hall," Lake Forest, Ill., for the Collegiate Year 1869–70. Lake Forest, Ill.: Ferry Hall, 1870.

The Little Review, March 1914–May 1929.

Los Angeles Times, January 1910–December 1929.

Mother Earth, March 1906–August 1917.

New York Times, March–July 1914; February 1922.

Official Catalogue of the Exhibitors, Panama-Pacific International Exposition. San Francisco: Wahlgreen Co., 1915.

Pacific Printer, October 1916.

Photo-Era, January 1910–December 1923.

Photograms of the Year, 1910–23.

Platinum Print [renamed *Photo-Graphic Art* in 1916], October 1913–October 1917.

San Francisco Chronicle, January 1930–December 1931.

Studio Light, July 1916.

Vogue, January 1926–December 1931.

Various photography salon catalogues and brochures from the years 1910–1925, including examples produced by the Camera Pictorialists of Los Angeles; the Los Angeles Camera Club; the Southern California Camera Club; the MacDowell Club of Los Angeles; the Friday Morning Club of Los Angeles; the California Arts Club of Los Angeles; the Los Angeles Museum of Science, History, and Art; the *Rafu Shimpo (Los Angeles Japanese Daily News)*; the San Diego Museum; the Oakland Municipal Art Gallery; the Pictorial Photographic Society of San Francisco; the John Wanamaker Department Store, Philadelphia; the Frederick & Nelson Department Store, Seattle; the Emporium Department Store and Gump's Department Store, San Francisco; the Pittsburgh Salon; the Wilkes-Barre Camera Club; the National Arts Club, New York; the Brooklyn Museum; the Pictorial Photographers of America; the American Photography Annual Competition; the London Salon of Photography; the Royal Photographic Society Salon; the Salon International d'Art Photographique in Ghent, Belgium; and the Copenhagen Photographic Amateur Club.

Anderson, Margaret. Papers. Milwaukee Urban Archive, Golda Meir Library, University of Wisconsin, Milwaukee.

Baruch, Ruth-Marion. *"Edward Weston: The Man, the Artist, and the Photographer."* Master's thesis, Miami University, Oxford, Ohio, 1946.

California Arts Club. Scrapbooks, 1910–30. Archives of American Art, Washington, D.C.

Conger, Amy. *"Edward Weston's Early Photography, 1923–1926."* Ph.D. diss., University of New Mexico, Albuquerque, 1982.

Connell, Will. Archive. Special Collections, University Research Library, University of California, Los Angeles.

Cook, George Cram. Papers. Berg Collection, New York Public Library.

Coryell, Russell. Papers and Scrapbooks. Stanis Coryell Collection, Cold Spring Harbor, New York.

Cunningham, Imogen. Papers. Archives of American Art, Washington, D.C.

Dell, Floyd. Papers. Newberry Library, Chicago.

Eastman, Max. Papers. Lily Library, Indiana University, Bloomington.

Friday Morning Club. Scrapbooks, 1910–25. Huntington Library, San Marino, Calif.

Gerson, Dr. T. Perceval. Papers. Special Collections, University Research Library, University of California, Los Angeles.

Glass [Taylor, Emily Harvin], Maud Emily. Papers. Special Collections, University Research Library, University of California, Los Angeles.

Hagemeyer, Johan. Archive. Center for Creative Photography, University of Arizona, Tucson.

Hartmann, Sadakichi. Archive. Special Collections, Tomás Rivera Library, University of California, Riverside.

Justema, William, and Margrethe Mather. *Exposé of Form,* Transcripton of original 1929 grant application. Archives of the John Simon Guggenheim Memorial Foundation, New York.

Katz [Kopelanoff, Household, Brandner], Betty. Papers. Martin Lessow Collection, Breckenridge, Colorado.

Krasnow, Peter and Rose. Papers. Archives of American Art, Huntington Library and Art Gallery, San Marino, Calif., and Aimée Brown Price Collection, New York.

Lerner, Miriam. Papers. Bancroft Library, University of California, Berkeley.

The Little Review. Records, 1914–64. Manuscript Collection, Golda Meir Library, University of Wisconsin, Milwaukee.

Los Angeles Museum of Science, History and Art. Scrapbooks, 1910–25. Special Collections, Los Angeles County Museum of Natural History.

Newhall, Nancy. Papers. Getty Research Institute for the History of Art and the Humanities, Los Angeles.

Reynolds, Florence. Papers. Special Collections, University of Delaware Library, Newark.

Rosen, Roy. Archive. University of New Mexico, Santa Fe.

Scharfe, Siegfried. Photographic archive of Frank Lloyd Wright architecture. Getty Research Institute for the History of Art and the Humanities, Los Angeles.

Wagner, Rob. Papers. Special Collections, University Research Library, University of California, Los Angeles.

Weston, Edward. Archive. Center for Creative Photography, University of Arizona, Tucson.

———. Biographical File. Glendale Public Library, Glendale, Calif.

Wilshire, Gaylord. Papers. Special Collections, University Research Library, University of California, Los Angeles.

Works Progress Administration Drawings of Bunker Hill, c. 1939. Los Angeles City Archives.

INTERVIEWS

Angel, Jenifer. Tape-recorded interview with author. 11 August 1998.

Chadwick, Myrna. Telephone interviews and correspondence with author. October–November 1997.

Cooper, Jean. Telephone interviews and correspondence with author. July–August 1998.

Coryell, Stanis. Tape-recorded interview with author. 25 April 1999.

Cunningham, Imogen. Interview by Edna Tartaul Daniel. June 1959; 1331 Green Street, San Francisco. *Portraits, Ideas and Design.* Transcript of tape recordings. Regional Cultural History Project, The Bancroft Library, University of California, Berkeley, 1961.

Eastman, Yvette. Interview with author. 15 March 1999.

Gilmer, Penny. Telephone interviews and correspondence with author. July 1998.

Glass, Gordon. Tape-recorded interview with author. 25 January 2000.

Hagemeyer, Johan. Interview with Corinne L. Gilb. May and July 1955, Hagemeyer's home and studio, Berkeley, Calif. *Johan Hagemeyer Photographer.* Transcript of tape recordings. Regional Oral History Office, The Bancroft Library, University of California, Berkeley, 1957.

Lessow, Martin. Telephone interviews with author. 8 October 1998 and 2 February 1999.

Martinez, Elsie Whitaker. Interviews by Franklin T. Walker and Willa Klug Baum. 10–13 September and 18 December 1962; 8 May and 9 July 1963; 324 Scenic Avenue, Piedmont, Calif. *San Francisco Bay Area Writers and Artists.* Transcript of tape recordings. Regional Oral History Office, Bancroft Library, University of California, Berkeley, 1969.

Pitts, Sandra. Telephone interviews and correspondence with author. October 1997–March 1998.

Rapp, Virginia Venable. Telephone interview with author. 4 April 2000.

Rosen, Alex. Tape-recorded interview with author. 18 January 1999.

Thomson, Dody Weston. Telephone interview with author. 4 April 1999.

Wilson, Charis. Telephone interview with author. 4 November 1997.

Wilson, Leon. Telephone interview with author. 11 November 1997.

CITY DIRECTORIES

Glendale (Tropico prior to November 1918) City Directories. 1890–1950. Special Collections, Glendale Public Library, Glendale, Calif.

Los Angeles City Directories. 1880–1952. Los Angeles Public Library, Los Angeles, and Newberry Library, Chicago.

New York City Directories. 1880–1930. New York Historical Society, New York.

Salt Lake City Directories. 1880–1931. Newberry Library, Chicago, and Family History Center, Salt Lake City, Utah.

San Francisco City Directories. 1905–15. San Francisco Public Library, San Francisco, and Newberry Library, Chicago.

UNPUBLISHED RECORDS

FAMILY RECORDS

Jungren Family Bible and Family Histories, Myrna Chadwick Collection, Salt Lake City, Utah:

Emma Caroline Youngren [Jungren, Younggreen; Margrethe Mather; Margaret Lipton], b. 4 March 1886.

CEMETERY RECORDS

City Cemetery, Salt Lake City, Utah:

Annie C. Youngren, b. 21 August 1884; d. 11 November 1886.

James [Gustav] Youngren [Jungren, Younggreen], b. 2 May 1888; d. 20 November 1916.

Peter Alfred Youngren, b. 16 March 1889; d. 2 July 1889.

Ane Sophie Jensen [Laurentzen, Lorentsen, Lorentzen] Youngren, b. 10 December 1860; d. 23 March 1889.

Ane Margrethe Petersen Jensen [Laurentzen, Lorentsen, Lorentzen], b. 25 January 1822; d. 27 November 1902.

IMMIGRATION RECORDS

Latter Day Saints, European Emigration Card Index, Microfilm #0298435, Jongsma—Michael:

Mine [Rasmine] Lorentzen [Jensen, Laurentzen, Lorentsen], on 10 July 1880, sailed from Liverpool, England, on ship *Wisconsin*; arrived New York 21 July 1880; continued journey by rail to Salt Lake City, Utah Territory, 29 July 1880.

Anna Margrethe Lorentsen [Jensen, Laurentzen, Lorentzen], with Jensine Jensen, on 25 June 1881, sailed from Liverpool, England, on ship *Wyoming*; arrived New York 7 July 1881; continued journey by rail to Ogden, Utah Territory, 15 July 1881.

CENSUS RECORDS

1880

E.[dward] B.[urbank] Weston Household:
Alice J. Weston, Mary Weston, May Weston, Matie (?) Weston
Deerfield Twp., Highland Park, Ill.

1900

Edward B.[urbank] Weston Household:
Minnie Weston, Palmer R. Randolph, Edward Weston, Francis J. Palmer
3847 Langley Avenue, Chicago, Ill.

Minnie Laurentzen [Jensen, Lorentsen, Lorentzen] Household:
Joseph C. Mather, Emma Caroline Younggreen [Jungren, Youngren]
844 South West Temple, Salt Lake City, Utah.

1910

James [*sic*] C.[ole] Mather Household:
Minnie Jensen [Laurentzen, Lorentsen, Lorentzen]
844 South West Temple, Salt Lake City, Utah.

Alice Green Household:
Margaret Mather [incorrectly indexed as Margaret Mother], I. L. Hart, Cecilia Herman, Anna C. Rolston, George B. Howard, Clarence M. Like
1291 Pine Street, San Francisco, Calif.

Edward H. Weston Household:
Flora M. Weston
Chandler Ranch, San Fernando Road, Los Angeles, Calif.

1920

Margrethe Mather Household:
715 West Fourth Street
Los Angeles, Calif.

Edward Weston Household:
Flora M. Weston, Edward C.[handler] Weston, Theodore B.[rett] Weston, Lawrence N.[eil] Weston, Frayne [Cole] Weston, Chandler Tract, Los Angeles, Calif.

MARRIAGE RECORDS

J.[oseph] C.[ole] Mather and Minnie [Rasmine] Jensen [Laurentzen, Lorentsen, Lorentzen]. Marriage Certificate, 7 July 1911, Salt Lake City. Department of Vital Records, County Clerk's Office, Salt Lake City, Utah.

DEATH RECORDS

Cornelius C. Chandler, Los Angeles. Death Certificate, 28 November 1911. Cause of death: vascular disease of the heart; arterial sclerosis. Department of Health Services, State of California, Sacramento.

Joseph Cole Mather, Salt Lake City. Death Certificate, 1 September 1916. Cause of death: senility. Department of Vital Records, State of Utah, Salt Lake City.

James [Gustav] Youngren [Jungren, Younggreen], Salt Lake City. Death Certificate, 20 November 1916. Cause of death: pneumonia. Department of Vital Records, State of Utah, Salt Lake City.

Anne Elizabeth (Denick) Chandler, Glendale. Death Certificate, 16 January 1919. Cause of death: diabetes mellitus. Department of Health Services, State of California, Sacramento.

William Justema, San Francisco. Death Certificate, 7 January 1987. Cause of death: cardiorespiratory arrest. Department of Health Services, State of California, Sacramento.

Minnie [Rasmine Jensen, Laurentzen, Lorentsen, Lorentzen] Mather, Salt Lake City. Death Certificate, 21 December 1931. Cause of death: cerebral hermorrhage. Department of Vital Records, State of Utah, Salt Lake City.

Margaret Lipton [Emma Caroline Jungren, Youngren, Younggreen; Margrethe Mather], Los Angeles. Death Certificate, 25 December 1952. Cause of death: multiple sclerosis. Department of Health Services, State of California, Sacramento.

George Lipton [Liberman], Los Angeles. Death Certificate, 2 November 1955. Cause of death: acute myocardial infarction. Department of Health Services, State of California, Sacramento.

Edward Henry Weston, Carmel. Death Certificate, 1 January 1958. Cause of death: paralysis agitans. Department of Health Services, State of California, Sacramento.

ACADEMIC RECORDS

Emma Caroline Youngren/Younggreen, Salt Lake High School Register, 1900–1905. Utah State Archives, Salt Lake City.

Acknowledgments

Serendipity played a vital role in the making of this book and the museum exhibition that accompanies it. It was a chance meeting with Karen Sinsheimer, curator of photography at the Santa Barbara Museum of Art, that first led to discussions of a joint display of the photographs of Margrethe Mather and Edward Weston. Karen immediately took the project on and secured the support of the Santa Barbara Museum of Art's executive director Robert Frankel, and the Board of Trustees, which allowed my research to begin. The collector Michael Wilson, whose own interest in early-twentieth-century California photography is widely known, had already established a precedent for the aesthetic dialogue that informs this study. Without the Santa Barbara Museum of Art and its advocates, Margrethe Mather and her work might have remained forgotten.

Remarkable coincidences began to occur about a month into the research process, turning what had begun as an intriguing, short-term exercise into a three-year quest with twists and turns I could never have anticipated. As answers to riddles fell into place, new and unexpected obstacles taxed every ounce of sleuthing ability I could muster. Ultimately, this art history mystery was solved through the cooperation, input, and encouragement of many people. Every one of them added a fresh perspective on some aspect of Mather's work, or a new bit of information about her character; every one gave generously of their time and memories. Although I located only four individuals who had known Mather personally, many others recalled hearing about her from their parents or grandparents. Several were willing to let me interview them and tape record their reminiscences. Others spent hours on the telephone answering questions about all manner of arcane subjects. Still others went to trunks in the attic, searching for scrapbooks or long-forgotten correspondence, and returned with previously unknown photographs by Mather.

Considerable information about Mather also came from correspondence and early-twentieth-century periodicals preserved in a wide array of research institutions. Reference librarians across the country extended themselves to help unravel the details of Mather's life so I could better gauge how her career had intersected with Edward Weston's. These seasoned professionals understood that names and events casually mentioned in a letter might provide vital clues about Mather and Weston's circle of friends, their lifestyle, attitudes, activities, and interests. They were so right. Each name led to another. Every manuscript archive yielded new and valuable information that pointed the way to the next discovery.

The most important leads came from the visual evidence—the photographs created by Mather and Weston during the years they worked together. The decade I spent as the director of Sotheby's New York Photographs Department had given me a firsthand familiarity with Mather's work and convinced me that she had been an influential photographer, not just in Weston's artistic development, but in a broader sense as well. I set out to locate as many Mather photographs as possible to test my theory. Collectors and museums graciously responded by sharing works from their collections, both for reproduction in this book and for inclusion in the exhibition. Photography dealers were particularly generous in allowing me access to their encyclopedic knowledge, libraries, and prized ephemera. The Family History Library of the Church of Jesus Christ of Latter-Day Saints and the Utah State Archives provided historical documentation that enabled me to uncover Mather's childhood identity and a few basic facts of her adolescence (including even her high school report cards). I then contacted descendants of Mather's Utah relatives, who sketched in more of her early history. In my early discussions with them I was careful to refer to her, as they did, only as "Emmy" Youngren, the lovely but melancholy little girl whose likeness, preserved in a nineteenth-century family photograph, was unmistakably that of the youthful Margrethe Mather. These relatives also provided the final, anecdotal corroboration of Mather's reinvention of herself when, unprompted by me, they characterized "Emmy" as a distant cousin who had left behind her Mormon upbringing to become a photographer in California.

To all of the following people and institutions, for a myriad of reasons, I am extremely grateful: Peter Adams, President, California Art Club; Pat Albers; Russ Anderson; Jim Andrews; Jenifer Angel; Paul Avrich; Neil Baldwin; Anitra Balzer; Bancroft Library, University of California, Berkeley; Miles Barth; Anne Barzel; Joseph Bellows; Sid Berger and Gladys Murphy, Special Collections, Rivera Research Library, University of California, Riverside; Joseph Bellows; Mirel Bercovici; Denise Bethel and Christopher Mahoney, Sotheby's Photographs Department; Hilda Bijur; Susan Burks; Doris Bry; Myrna Chadwick; Chicago Historical Society; Chicago Public Library; Carolyn Cole, Los Angeles Public Library; Virginia Comer; Valentina Cook; Amy Conger; Jean Cooper; Stanis and Bea Coryell; Stephen Daiter; Keith Davis, Hallmark Collection; Uini Davis; Richard Dearborn; David Dechman; Keith Delellis; Ann Lewin Diament; Mary Dillwith; Steven Drew, California State Railroad Museum; Jacqueline Dugas, The Huntington Art Collections; Judy Duque; John Durham, Bolerium Books; Yvette Eastman; Susan Ehrens and Leland Rice; Simon Elliott, Young Research Library, University of California, Los Angeles; Yvonne Boursault Fairchild; Kathleen Ferris, Special Collections, University of New Mexico Library; Peter Fetterman; Cynthia and Walter Flor; Harry Ford; Lynn Fors, Special Collections, University of Illinois Library, Champaign-Urbana; Jeffrey Fraenkel; Peter Galassi, Museum of Modern Art; Susan and Scott Garrett; Lyman Gaylord; Penny

Gilmer; Gordon and Mimi Glass; Nora Goldsmith, Glendale Public Library; Glendale Historical Society; Shelby Gray; Jonathan Green; Howard Greenberg; Beth Guynn, Getty Center for the Arts and Humanities; Karen Haas, Boston Museum of Fine Arts; Tim Hafen; Bob Haines, Argonaut Book Shop; Maret Halinen; Maria Morris Hambourg, Metropolitan Museum of Art; Norm Hammond; G. Ray Hawkins; Lorimer Hay-Chapman; Kurt Helfrich, University of California, Santa Barbara; Paul Hertzmann and Susan Herzig; Highland Park Public Library; Ana Hofmann; Elizabeth Duque Hotaling; the late John Humphrey; Jo Iampietro; Chris Imhoff and Scott Bernstein; Charles Isaacs; Buffie Johnson; Drew Johnson, Oakland Museum of Art; Richard Johnson; Alan Jutsi, the Huntington Library; Carol and Rana Kamal; Norman Karasick; Boris and Margo Kaufman; Jan Kesner; Mead Kibbe; Helen Kornblum; Joel Kroin; Gary Kurutz, California State Library; Barbara Smith Laborde, Harry Ransom Center, University of Texas; Isaac Lagnado; Lake Forest Public Library; Harry Lawton; Martin Lessow; Charles LeWarne; Library of Congress; Nancy Lieberman; Wistaria Hartmann Linton; Richard Lorenz; Los Angeles City Archives; Sarah Lowe; Vee Lyons; Lee Marks; Liz Marston; Ray Matthews, Utah State Archives; Robert McCracken; Suzanne McKay, Glendale Historical Society; Sally McManus, Palm Springs Historical Society; John Medveckis; Rebecca Johnson Melvin, Special Collections, University of Delaware Library; Professor Art Miller, Lake Forest College; Lee Miller, M. H. deYoung Memorial Museum; Joyce Milton; Mary Alice Molloy; Kathryn R. Nielson, T.R.U. Search Services; Newberry Library; New York Historical Society; New York Public Library; Beatrice Oshika; Mary Jane Parkinson; Elizabeth Partridge; Lori Pauli, National Gallery of Canada; Shannon Perich, National Museum of American History; Christian Peterson, Minneapolis Institute of Arts; Sandra Pitts; Terence Pitts, Amy Rule, and Leslie Calmes, Center for Creative Photography; Cathy Pollock and Marshall Price, Santa Barbara Museum of Art; Aimee Brown Price; Jane Purse; Karen Quinn; Diane Rapp; Virginia Venable Rapp; Dennis Reed; Michael Redmon, Santa Barbara Historical Society; Alexander Rosen; Richard Rudisill, University of New Mexico; Andree Ruellan; Jean and Aran Safir; Richard Sandor; San Francisco Public Library; San Francisco Museum of Art; Santa Barbara Public Library; Santa Monica Public Library; Amy Saret; Naomi Sawelson-Gorse; David Scheinbaum and Janet Russek; Mark Schindler; Paulette Silberberg; Barry Singer; Tom Sitton and John Cahoon, Los Angeles Museum of Natural History; Catherine Smith; Richard and Judy Smooke; Susan Snyder, Bancroft Library, University of California, Berkeley; Gary Sokol; Joel Soroka; Donnan Stephenson; Bette Stern; Rachel Stuhlman and Joseph Struble, George Eastman House; Dale Stulz; Robert Sweeney, Director, Schindler House; Elena Talimalie; G. Thomas Tanselle, the Guggenheim Foundation; Dace Taub, History Collection, University of Southern California; Saundra Taylor, Special Collections, Lily Library,

Indiana University; Dody Thompson; Judy Throm, Archives of American Art; Janell Tuttle, Utah State Historical Society; Leonard Vernon; Kate Ware, Philadelphia Museum of Art; Jenny Watts, the Huntington Library; Rick Wester, Christie's Photographs Department; Cole Weston; Maggi Weston; Laurie Whitcomb, Pasadena Public Library; Steve and Mus White; Victoria White and Joe Hupton; Patricia Willis, Beinecke Library, Yale University; Charis Wilson; the late Leon Wilson; the late Lee Witkin; Emily Wolf, California Historical Society; and Tim Wride, Los Angeles County Museum of Art.

A small group of individuals deserves special recognition because they were the first to acknowledge Mather's significance: the late Nancy Newhall, who initially explored and recorded the importance of Mather's influence on Edward Weston; the late Ben Maddow, who reiterated Newhall's sentiments; the late William Justema, whose lively memoir suggested as many questions as it answered; the late Lee Witkin, who placed Justema's collection of Mather's photographs with the Center for Creative Photography, and Jim Enyeart, former director of the Center, who had the foresight to acquire the work when he had the opportunity; Lawrence Jasud, who authored a brief but enlightening essay about Mather's work; the late Roy Rosen, who went on record as a firsthand observer of Mather and Weston's relationship; Weston Naef, who curated the first half of the 1986 exhibition *Edward Weston* in Los Angeles; and the late Imogen Cunningham, who vehemently expressed her lifelong admiration for Mather's talent to anyone who would listen.

A special thanks goes to Anne Horton, my colleague and friend, whose longstanding interest in Margrethe Mather sparked my own; to Michael Dawson, the third generation Los Angeles bookman whose combined love for photography and Southern California history was an inspiration; to Ragdale, a place that reminded me how much we all need the time and space to be creative; to A. S. Byatt, whose luxuriant prose has so compellingly captured the obsession behind the search; to Jim Mairs, my editor at W. W. Norton, whose enthusiasm and determination made this book possible, and to Jill Quasha, the mutual friend who introduced us; to Katy Homans, who designed the elegant layout; to my mother, Bernadine Hays Gates, whose residency in Santa Barbara precipitated my association with the Santa Barbara Museum of Art; and, most of all, to my husband, Robert Boghosian, whose support and understanding never wavered for a moment.

BETH GATES WARREN

Index

DATE DUE